NASHVILLE'S LOWER BROAD

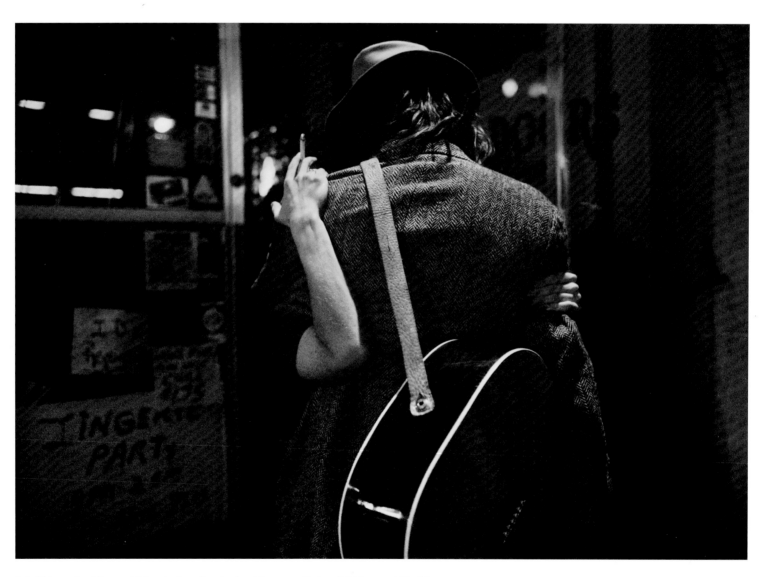

Jule Tabor, the Minstrel Man, before beginning his set at Robert's Western World.

NASHVILLE'S LOWER BROAD
The Street That Music Made

Photographs by Bill Rouda

Foreword by Lucinda Williams • Introduction by David Eason

Smithsonian Books

Washington

Copy Editor: Gretchen Smith Mui

Production Editor: Joanne Reams

Designer: Brian Barth

Jacket Designer: Janice Wheeler

Library of Congress Cataloging-in-Publication Data

Rouda, Bill.

 Nashville's Lower Broad: the street that music made / photographs by Bill Rouda; foreword by Lucinda Williams; introduction by David Eason.

 p. cm.

 ISBN 1-58834-094-5 (cloth: alk. paper)

 1. Broadway Avenue (Nashville, Tenn.)—Pictorial works. 2. Nashville (Tenn.)—Social life and customs—Pictorial works. 3. Nashville (Tenn.)—Social conditions—Pictorial works. 4. Bars (Drinking establishments)—Tennessee—Nashville—Social conditions—Pictorial works. 5. Country musicians—Tennessee—Nashville—Social conditions—Pictorial works. 6. Documentary photography—Tennessee—Nashville. 7. Country music—Tennessee—Nashville—History and criticism. I. Title.

F444.n275B76 2004

976.8'55—dc22 2003059556

British Library Cataloging-in-Publication Data is available

Printed in China

10 09 08 07 06 05 04 5 4 3 2 1

⊗ The paper used in the publication meets the minimum requirements of the American National Standard for Information Sciences—Permanence of Paper for Printed Library Materials ANZI Z39.48-1984.

For permission to reproduce illustrations in this book, please correspond directly with the owner of the works. Smithsonian Books does not retain reproduction rights for these illustrations individually or maintain a file of addresses for photo sources.

Lyric Credits

"Honky Tonk Blues," © 1948 (renewed) Sony/ATV Acuff Rose Music. All rights on behalf of Sony/ATV Songs LLC administered by Sony/ATV Music Publishing, 8 Music Square West, Nashville, TN 37203. All rights reserved. Used by permission.

"Me and Paul," words and music by Willie Nelson © 1971 (renewed 1999) Full Nelson Music, Inc. All rights controlled and administered by EMI Longitude Music. All rights reserved. International Copyright secured. Used by permission.

"Spokane Motel Blues," © 1973 Sony/ATV Acuff Rose Music. All rights on behalf of Sony/ATV Songs LLC administered by Sony/ATV Music publishing, 8 Music Square West, Nashville, TN 37203. All rights reserved. Used by permission.

"Travellin' Minstrel Man," © 2003 Sony/ATV Songs LLC. All rights administered by Sony/ATV Music Publishing, 8 Music Square West, Nashville, TN 37203. All rights reserved. Used by permission.

CONTENTS

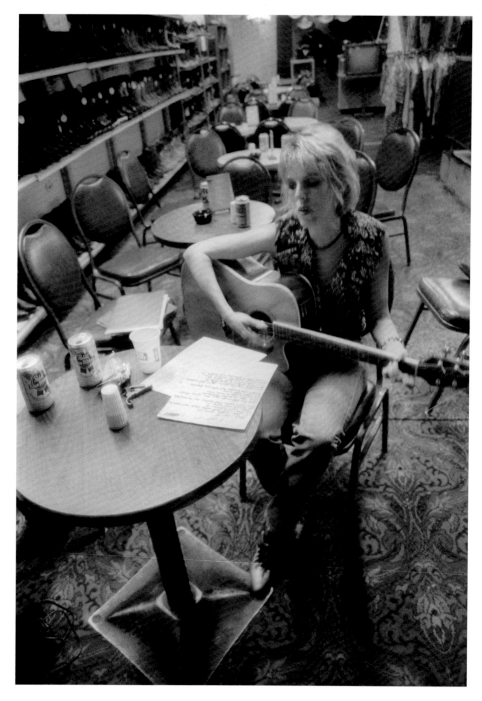

Lucinda Williams works on a song at
Robert's Western World.

FOREWORD

I went to Nashville looking for something different. I'd been living in Los Angeles for a few years after ten years of hanging out in Austin and Houston. The scene had started to change in L.A., and I'd spoken with a couple of friends who had found a comfortable vibe in Nashville and suggested I try it. I'd given it a shot in 1983 and hadn't liked it much. It was winter then, and my boyfriend, Clyde, and I were passing through town and staying with our friend, the songwriter Richard Dobson. To celebrate my birthday we headed downtown to get a feel for the old, true Nashville that we'd read about in books and heard about in songs. What we found were a few run-down little wino bars housing wanna-be country singers singing worn-out versions of cover songs, so we headed west and I ended up living in L.A. for the next six years. Then it was time to leave again.

In January 1993 I decided to give Nashville another try. What I found was similar to the picture in my mind that I'd left with ten years earlier. There were a couple of hipster bars, but aside from those places I didn't feel very com-fortable going out anywhere in my black-leather jacket and motorcycle boots, so I really wasn't sure that I was going to stay. Then I got a call from an old friend I'd known back in Texas. Through her I was introduced to the writer Dub Cornett, and through Dub I met the songwriter R. B. Morris, the folk artist Kevin Bradley, and Billy Rouda. We were a gang of intellectual, bohemian hipsters, and we decided that we were going to find out where something was hap-pening or make something happen. We banded together about town with the sense that we were part of something new and undiscovered.

Forget New York and L.A. We knew something was brewing underneath the broken-down, dusty, working-class bars and the worn-out cover songs of downtown Nashville. Over the next couple of years other artists began moving in and bringing their own brand of original music to those old bars. Now we had a scene. We had resurrected Lower Broad, and Billy Rouda was always there with his camera, quietly documenting the little "undis-covered" area. He had the foresight to preserve this little

piece of history in the making. Through his lens Billy helped us see the real heart and soul of Nashville. Now we could invent a new story and a new song.

Then things began to change. The corporations and the money moved in. They tore down the old buildings and put in a Planet Hollywood and a Hard Rock Cafe. They cleaned up Music Row. They tore down the hot dog stand and cleared out Barbara Mandrell's Tourist Shop. They moved the Country Music Wax Museum and the Midnight Jamboree. All the sweet, original landmarks that spoke of the romance and creativity of an earlier time were replaced by fern bars and condos.

After we had made it hip, our little scene had been found out. Now they wanted it for their own.

A long time ago downtown Nashville had been alive. It died and was brought back to life for a while. It's gone away again, and what's in its place is worse than the picture I had in my mind twenty years ago. But now you have Billy Rouda's photographs. They will give you a much clearer picture of what I've been struggling to describe. Look, listen, and learn.

Lucinda Williams

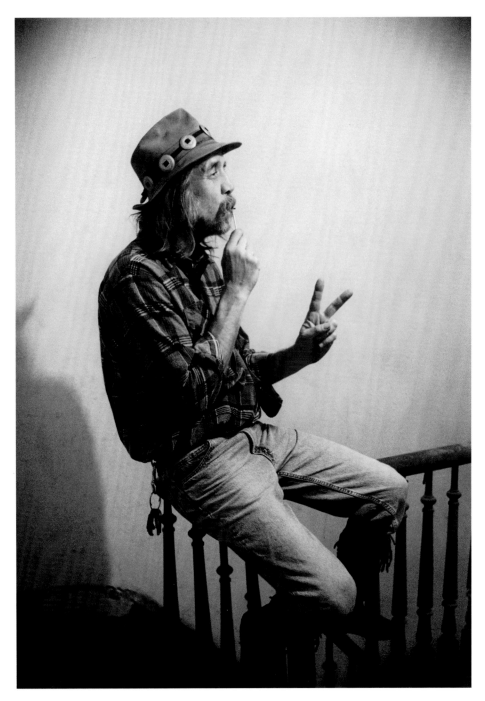

On the street, Jule Tabor is known as the
unofficial mayor of Lower Broadway.

Gary Bennett, Greg Garing (at the mike), and Chuck Mead on the back stage at Tootsie's.

PREFACE

In 1993, dissatisfied with the direction of my career, I closed my commercial photography studio to pursue my true passion: documentary art photography. A visit to Nashville, Tennessee, in October of that year marked the beginning of a journey that would recharge my vision as a photographer and lead me to witness the passing of a unique time in the life of a city and a culture.

I did not go to Nashville with the intention of making this book but simply to visit a songwriter friend. At a party I attended the night I arrived I found myself among some of the finest American lyricists I had ever heard. In this informal setting they sang about the pain and pleasures of real life—love and hope, heartaches and triumphs. Inspired, I found myself wanting to photograph not the singers but the songs themselves.

This was not my first encounter with the music of my native South. When I was a teenager growing up in the foothills of the Carolinas, the folk music revival had made its way to a small group of us in the mid-1960s. We spent many summer days roaming the Blue Ridge range of the Appalachian Mountains, heading down gravel roads to the porches of pickers, to rural community centers and on

Saturday nights to high school gyms for small shows, and some weekends to music festivals or "fiddlers' conventions," as they were called. We were searching for the music of the land. In Nashville, I picked up the trail.

In the following months I made several trips to Nashville trying to figure out how to translate my feelings into photographs. I found out how in the unlikeliest of places: the honky-tonks on Lower Broadway. Bringing with me not much more than wonderment, I moved to Nashville and started documenting the honky-tonks and musicians struggling and surviving along Lower Broad, an effort that would bring me closer to understanding some of the people caught up in the world of American music.

I approached my project with great simplicity, using only two cameras, a few lenses, and rarely any additional lighting other than street or stage lighting. I learned early on that strobes seemed to intimidate people and make them pose for the camera, so I opted for a less intrusive method that would allow me to blend in and make candid, unbiased photographs. My intention was to hide myself in the street, becoming a regular and something of a street character myself. I wanted to feel and see what my subjects

felt and saw and translate that to film. I concealed my equipment in an army surplus satchel, grew a ponytail, and shot freely. As people began to accept me, they also allowed me to record their world on film.

Because of the technical difficulties presented by shooting fast action in low light, I often had to push my cameras and film to their limits. But I felt that capturing the subject was more important than using slow, fine-grain film, maximum depth of field, and fast shutter speeds that would have made my subjects appear to be under studio conditions. Sometimes I even shot with no film in my cameras, just to give people a chance to get used to being photographed.

I made many friends on Lower Broadway. I became fascinated with the street's array of characters and how fast things could change, all with music constantly playing in the background. You never knew who might walk in off the street, get on stage and play, and either bring the house down or run people out. Two or three or more friends might have a little too much to drink, get rowdy and out of hand, and the next minute have their arms around one another, the best of buddies again. Or a star—a has-been, a wanna-be, a never-will-be, or a might-be—might show up. What was happening one minute never seemed to give any indication as to what might happen the next. Sometimes it seemed as if I were in a movie with no script.

But it was the aspects of the street as it changed from skid row to the hippest place in town to a sanitized representation of itself that interested me, the mix of characters: people of the night; record label executives in designer suits, talking on cell phones; fresh-faced college students; winos and hookers; working-class Americans; European and Japanese tourists in cowboy hats—all enjoying the music with the mystical muse of the past seeming to guide the way. All the regulars on the street worshiped the music, which so clearly touched their souls. The musical legends of the past, some of whom had gotten their start on Lower Broadway, cast long shadows over the street, where they were spoken of as family members. Probably not all the stories were true, but the passion the stories were told with made them worth listening to. I found myself wanting to believe them.

Lower Broadway was a complex world, one of the most intriguing places I had ever seen. I had the sense that just about anything could happen there, wild or wonderful. One cold gray day in November 1995, for instance, I was sitting in Tootsie's when a man came in to discuss the production details for an upcoming television show scheduled to be shot in Tootsie's and to feature Willie Nelson, Kris Kristofferson, and many regulars from the old days. We began to talk, and before he left I had been hired to do production stills. I felt as if I was living one of those stories where deals were made with a handshake and a contract written on a bar napkin.

The production started a few days later at Tootsie's and ended at the Ryman Auditorium. Afterward I walked out on the Ryman's stage and stood in the center of a quiet, empty room. I had heard so many stories about the sensation experienced by performers on the stage that the Grand Ole Opry had made famous. For me, it was a little like standing on holy ground, as if legions of spirits from the past were present and watching over the mother church. I felt that I was conjoining with the muse and connecting with those spirits. Photographing these musical icons in something resembling their original setting was a once-in-a-lifetime experience that had come about by my being in the right place at the right time—but that's Broadway for you!

The spirit of American music is rich. I feel fortunate to have been able to record a bit of its history while questing after the passion of the poets and pickers of Lower Broadway.

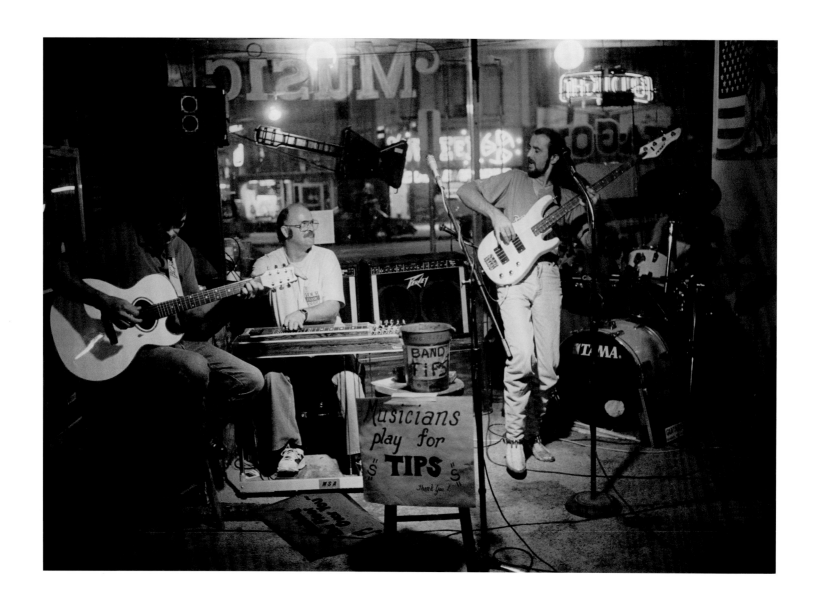

There's live music from morning until night seven days a week on Lower Broadway, and the musicians, like these at the Wagon Burner Lounge, play mostly for tips.

LONGING FOR A SONG

Nashville's Lower Broadway in Good Times and Bad

DAVID EASON

Well I left my home down on the rural route. / Told my folks I'm going stepping out / And get the honk-y tonk blues, / The weary honk-y tonk blues. Well Lord, I got em, I got the honk-y tonk blues.
—HANK WILLIAMS, "HONKY TONK BLUES"

I guess Nashville was the roughest, / But I know I said the same about them all; / We received our education in the cities of the nation, / Me and Paul.
—WILLIE NELSON, "ME AND PAUL"

If you love the old songs that made Nashville, Tennessee, the home of country music, it's difficult to stand on the Opry Corner downtown and not long for the time when the sounds of the Grand Ole Opry filled the Ryman Auditorium every Saturday night, Tootsie poured the beer at the Orchid Lounge, and the Midnight Jamboree at the Ernest Tubb Record Shop on Broadway pointed the way to Sunday morning. Today that corner is marked by the glassy facades of the Gaylord Entertainment Center and the Nashville Convention Center. Just to the south on Fifth Avenue are a Hilton Hotel and the Country Music Hall of Fame. This new city introduces a sense of scale that dwarfs the old structures and crowds out memory. The past, which in one moment feels so close, in another feels small, fleeting, fighting for its life.

Broadway has been a street of longing since the 1940s, when the Grand Ole Opry moved to the Ryman Auditorium. That longing stares out of the old photographs of Opry crowds waiting for the show to begin, fills the stories that Willie Nelson, Tom T. Hall, and others have told about the hopeful songwriters who gathered at Tootsie's Orchid Lounge, and drives the vivid portrayals of

Broadway by the wave of writers who chronicled the Nashville Sound after Patsy Cline and Jim Reeves moved the music closer to the mainstream.

The Opry left the Ryman for the suburbs in 1974, but the tourists still came to Broadway, where the music played on in a string of bars. Here was the world that country music songs evoke, and in these honky-tonks the songs had come to life. If you were trying to launch a music career, however, Lower Broadway became the last place you wanted on your resume. Broadway had become a street where, in the words of the street poet Jule Tabor, "anything can happen and usually does," and polite society avoided it. The street became known for lawlessness, and every violent act was amplified to fit the theme. By the late 1980s the *Nashville Scene*'s Best of Nashville awards annually named Lower Broad "the place you most don't want to be alone after dark."

A child of the rural South, I have spent most of my life in cities, many of them in the North and West, but I always found a bar or a honky-tonk, usually with country music on the jukebox, to call home. I liked the booths, the dark, the beer signs, the friendliness, the music, and, for a long time, the beer. I found a connection to my past in these joints, a temporary solution to the problem of displacement. In 1972 I was living in Memphis and drinking my beer at the original Poor and Hungry Cafe on Madison. The jukebox was full of country songs. One of my favorites was Tom T. Hall's "Spokane Motel Blues," a song about being stuck on the road in the Northwest. Tom T. yearns

for warm, friendly places, among them Tootsie's. "I wish I was down at Tootsie's eating chili," he sings. I didn't know about Tootsie's, but I liked the song enough to feel homesick for a place I had never been. It would be six more years before I would visit Tootsie's. She was dying by then, the Opry was gone, and Broadway looked threadbare. I was living in Milwaukee and in the summers often visited Nashville. I would drink beer at Tootsie's through the afternoon, plugging the jukebox and watching the street characters out the open door. I moved to Salt Lake City in 1983 and didn't get back to Nashville for a few years, but I kept a photograph of the bar at Tootsie's on the wall of my office until I moved here in 1990.

I started going back to Lower Broadway in the mid-1990s. The street was getting a makeover—the Ryman Auditorium was reopening after twenty years, a new arena was going up, and a string of theme restaurants was working its way up the street from the river—but it was BR549, Greg Garing, and Paul Burch and their hot, youthful country sounds that drew me to Tootsie's and Robert's Western World. Bill Rouda became familiar to me in the way you get with people you stand beside in small clubs night after night without ever being introduced. I finally met him one night at a Lucinda Williams show and learned that he was a photographer who had been documenting life on Lower Broadway for a couple of years. When I had the opportunity to see his photographs, I was much taken with their rawness and romance. Bill had captured the street starkly but with the affection of an insider. He had

been on Lower Broadway at a time when a new order was showing itself and making the old one visible in a new way. His photographs captured both those worlds and, sometimes, in ways I really couldn't explain, the mythic world that hung over Broadway too.

Bill introduced me to the bar owners and workers, musicians, and regulars, and I became interested in Broadway, its ways and mores, its history and myths. I went through old newspaper files, star biographies, and books and magazine articles about the music business in Nashville and interviewed the old-timers on the street. But I learned the most about Broadway by just hanging out and talking casually. My favorite times were sitting with Lois Shepherd while her husband, John, who has played on the street since the early 1970s, covered the five-to-nine shift at the Music City Lounge. Lois, a songwriter, has a good memory for details and soft ways that have withstood hard years. She made me remember the good times in all those other bars that had made me feel at home.

The Honky-Tonk across the Alley

The 400 block of Broadway entered country music history in 1943, when the Grand Ole Opry, a Saturday night barn dance broadcast on WSM radio, found a home just around the corner at the Ryman Auditorium, where it would stay for thirty-one years. During these years the Opry enjoyed its greatest influence, imprinting its sound on the consciousness of the white rural South and beyond,

becoming for a time the single most dominant institution in country music. During its heyday, the lines of people trying to get into the Opry trailed off Fifth Avenue onto Broadway and headed toward the river before again turning north on Fourth behind the Ryman. If you were halfway up Fourth Avenue, you weren't likely to get one of the Ryman's 2,200 seats, but the fans stood nonetheless and waited for some official word before wandering off to look for stars in the clubs, search the gift shops, or just have a few beers until the Midnight Jamboree.

Buddy Shupe remembered his first night in Nashville back in 1969. Shupe was heading to Oregon because the coal mining back home in Virginia had given out. He had misgivings, though, and got off the bus in Nashville to think about the move. "It was Saturday night and I was lucky enough to get a room in the Ross Hotel there at the corner of Ross and Commerce. All the windows were open at the Ryman and I was sitting in the window there at the hotel and I could hear Dolly and Porter doing 'The Old-Time Preacher Man.'" Shupe decided to stay put and made Nashville his home. Over the years he moved among many Opry performers. "The artists weren't so sophisticated as they are today. They mixed more with ordinary folks. There was a bar right across the street from the Ryman that they would all frequent. I knew Junior Samples, Grandpa Jones. I was in there the night the Bellamy Brothers came to town. They did their first song there."

During the early 1960s, country music softened its sound

to broaden its audience, and fans, flush with the dollars of an expanding economy and an improved interstate system, came longer distances with more money to see the show. The Opry expanded, moving its Friday night show from the studio to the Ryman. By 1968 *Harper's* reported that the typical Opry visitor was a blue-collar worker in his late twenties from the Midwest or South who had driven about five hundred miles by car to get to Nashville. With the Opry dominating Broadway on both Friday and Saturday nights, weekends became a carnival. On Fifth Avenue, there were gift shops and a couple of clubs across from the Opry. Right around the corner on Broadway were Tootsie's Orchid Lounge, Shot Jackson's Music Store, the Roy Acuff Exhibits, and the Sho-Bud Guitar Factory. Across Broadway were Linebaugh's Restaurant, which since the 1940s had catered to the country music crowd; the Ernest Tubb Record Shop, a fixture on the street since 1951; a couple of clubs—the Wheel, where Willie Nelson's first wife tended bar, and the Music City Lounge—and the Little Roy Wiggins Music Store, which had a local radio show on Saturday afternoon. In between these music-related spots were pawnshops, an occasional retail store, and, beginning in the mid-1960s, the emerging industry on the street, pornography: peep shows, massage parlors, and adult bookstores.

Tootsie's Orchid Lounge, which opened in 1960 and in a short time gained notoriety as a hangout for music people, was separated from the Opry by an alley off Fifth Avenue. A door from the alley opened onto the bar's back room, which Tootsie reserved for Opry performers. Those who drank and were willing to drink in public stepped across the alley to grab a beer and some conversation between their appearances. In the early sixties, songwriters and pluggers eager to sell songs gathered with recording company representatives there. Much business was started if not finished in that back room. Hank Cochran, who has written hits for Patsy Cline, Burl Ives, Eddy Arnold, Ray Price, Elvis Presley, Merle Haggard, and George Strait, was promoting songs for Pamper Music, a publishing company. The scene in Tootsie's, Cochran remembered, was very casual. "Everybody on Saturday would all just be sitting around singing and passing the guitar. Maybe later in the week, I would go down to where the person was and take them a demo. That was where Willie [Nelson] sang 'Hello Walls' for Faron Young. Then me and Willie took it over to him the next week."

If you were in the music business—or wanted to be—and were a beer drinker, the odds were that you passed through the bar. Hattie "Tootsie" Bess came from the world of country music. Her husband, Jeff Bess, had had several country bands, and she had been a comedienne in some of these before getting into the bar business. Tootsie was, by all accounts, a funny, warm-hearted woman who had a soft spot in her heart for the struggling musicians and songwriters who filled her bar. She joked and cajoled them through the evening hours, running a tab for them if they couldn't pay, before blowing her whistle at closing time and applying her famous hat pin to the rumps of those

who tarried too long. She put the songs of her favorites on the jukebox in hopes of catching the ear of the industry types. And when success didn't come or life's sorrows intruded in other ways, she listened to their sad stories as well. During the week Tootsie let the songwriters use the back room to work on songs. Justin Tubb and Roger Miller wrote "Walkin' Talkin' Cryin' Barely Beatin' Broken Heart" in the back room, and Hank Cochran wrote Johnny Paycheck's first hit, "A-11," there as well. Tootsie often told visiting writers that Roger Miller wrote "Dang Me," a comic song about the foibles of a barfly, "right there in that booth," but that may be a story that should be true and isn't.

Many of her crowd went on to become major performers, but Tootsie is remembered today, in large part, as a patron saint of songwriters. Among the songwriters she befriended was a group that provided some of country's enduring hits and broadened the definition of a country song: Willie Nelson, Harlan Howard, Hank Cochran, Roger Miller, Kris Kristofferson, Wayne Walker, Bobby Bare, Mickey Newbury, Tom T. Hall, Mel Tillis, and Waylon Jennings. Cochran, Howard, and Nelson provided the songs that lifted Patsy Cline to stardom in the early sixties: "I Fall to Pieces," by Cochran and Howard, "Crazy" by Nelson, and "She's Got You," by Cochran. "Crazy" is the number two jukebox single of all time and was named one of National Public Radio's one hundred most significant pieces of music of the twentieth century. "Crazy," "I Fall to Pieces," "Dang Me," and Miller's "King of the

Road" are all in the Grammy Hall of Fame. Kristofferson, who took country music into the bedroom, has two songs—"Help Me Make It through the Night" and "For the Good Times"—among Broadcast Music Incorporated's one hundred most-played songs of the twentieth century. In *Heartaches by the Number: Country Music's 500 Greatest Singles* (Vanderbilt University Press and the Country Music Foundation, 2003), David Cantwell and Bill Friskics-Warren chose songs by Tootsie's writers for two of their top three spots: "Help Me Make It through the Night" (number one) and "Crazy" (number three).

By the late 1960s, Tootsie's had become an essential stop for visitors, including the many writers who came to town to chronicle the rising popularity of country music. For the mostly working-class fans who came to Nashville, it was a place to have a beer and maybe catch a glimpse of a star in a tavern that probably didn't feel too much different from the ones back home. For those mostly middle-class readers of *The Saturday Evening Post, Harper's, Newsweek, The New Yorker,* and *The New York Times Magazine* who knew about the bar only from the stories they read, it was a portal to the country music world of Nashville and the broader world where country music played on in the lives of its fans. "Tootsie's," Charles Portis wrote for *The Saturday Evening Post,* "is like a thousand other beer joints in the South with such names as Junior's Dew Drop Inn and Pearl's Howdy Club, and a certain type of country boy feels right at home there, whether he has $250,000 in his pocket or just came in on the bus from Plain Dealing, La., with a guitar across

his back. . . . *This is the milieu of commercial country music, the Southern honky-tonk*" [emphasis added].

Nashville's Broadway had worked its way into the mythology of country music and had become a stage for telling the country music story to an urban world. The Opry represented a nostalgic world of wholesome values come to life through cornball comics, string bands, and the idealized setting of the barn dance. It had begrudgingly accommodated the amplified, bluesy honky-tonk sound of the 1950s, but its heart was still in the cornfields. Broadway was the city, a world of diners, bars, and increasingly, the troubles associated with contemporary cities as well: pornography, prostitution, and crime. George Gruhn, who opened his guitar store on North Fourth, right behind the Opry, remembers the mixed-up neighborhood he moved into in 1966. "When I came, the neighborhood had lots of winos, pimps, hookers, massage parlors. It was colorful. But for the most part it was nonviolent. It was sleazy, but it was still the one block where if any visitor in town was going to come to see the music, that was the block. There was booze, there was music, there was sex, drugs, but you start thinking what do musicians want? They want music, booze, sex, drugs. It was all there."

When the Opry moved, Broadway was cut off from the music business and slid down the class structure of the city. The street became a place to worry over or ridicule. Still, what happened to Broadway would matter more now because of its history. The lore of the back room at Tootsie's on Opry nights, the antics of the songwriters who claimed the 400 block as their home base, and the time when a man with $250,000 in his pocket rubbed arms with a country boy from Louisiana, would hover over the street—haunt it, if you believe the visions of the drunks—as Broadway became the thoroughfare of the lawless and the homeless.

The Wrong Side of the Street

I didn't spend much time at Tootsie's when I returned to Broadway in the 1990s. The bar had changed. It had closed three times and had been the subject of a couple of lawsuits, one of which had determined that the name "Tootsie's" went with the building. Another had settled a dispute between feuding partners and determined its owner. But mostly it was the feel of the room that had changed. A small space meant for conversation has become a performance space for the bands that play mostly for tips and are standard in the clubs on the street. Live music has been the mainstay of Broadway since the 1970s, and Tootsie herself added it after the Opry left. The bar still tries to cultivate the old homey atmosphere. Wanda Lohman, one of the waitresses from the old days, comes in a couple of days a week to spin stories. But mostly, Tootsie's feels like what it is: a shrine bar where you can buy a T-shirt and have a quick beer before moving on down the street.

I spent a lot of time across the street on what had been since the 1970s the wrong side of Broadway. In the after-

noon I would sometimes listen to Jason Capps, a young songwriter who crafts some good songs in the honky-tonk tradition and has a cut, "Pouring Pain," on a BR549 album. I also liked to hear Jule Tabor, who spent his mornings cleaning up over at Legends Corner and would sing a few songs on someone else's shift while waiting for a ride. Jule came to Broadway almost twenty years ago. He's the fast-talking "Minstrel Man," the title of both his book manuscript and a song of his:

> I'm just a minstrel man,
> traveling through your town
> I can sing of where I have been
> but I can't say where I'm bound.
> I can't say where I'm bound.

Like the songwriters that journalists have found in Nashville for forty years, Jule came to Nashville full of hope but without a plan. A song he wrote about meeting Willie Nelson won a contest in a Texas bar, and he headed out to Nashville "to test myself against the best." He left with one dollar and arrived here with that same dollar, he said. "I came here and slept on top of Tootsie's, under the bridges. It was wintertime and jobs was hard to come by. Ate out of a few dumpsters, but I didn't rob or steal or break into anywhere and didn't bum anybody for nothing—no chump change." He sang for a while at the old Merchants Hotel and worked construction until he fell and hurt his back. Then, for eight years, he lived in a van parked on the lot where the arena is now. He has done odd jobs up and down Broadway and sung in every club on the strip and on the street outside as well.

Nobody on Broadway was becoming a star when Jule arrived in 1983. David Allan Coe, who had played there in the 1970s, was the street's last claim to lifting someone to a major label contract. Jule celebrates what had become the best of alternatives on the street, avoiding having to go home beaten. It's an old story that has assumed the power of myth. A few years ago the Tractors used the story line for a video that was devoted to a cover of the Rolling Stones' song "Last Time" and shot on Broadway. In the video a young guy gets off the bus and wanders around looking for a place to play, but no one will hire him. He takes a wrong turn and finds himself in an alley where he's robbed. Finally, he hocks his guitar to buy a bus ticket home. In the station he passes another young musician getting off the bus. It's a never-ending story, the video suggests. Someone's last time is another person's first time, and like the road that brings them here, the story goes on forever.

Broadway was the boulevard of the poor for more than twenty years after the Opry moved in 1974, but it had been heading that way a few years before that. Like most American cities, Nashville started to suburbanize in the 1950s, and shoppers began to desert the downtown. As businesses left the Ryman area, it became a street devoted to pornography and honky-tonks—fourteen of them at one time in the late seventies. The area was becoming rough. There was prostitution, petty crime, and the threat

of violence. The blues singer Celinda Pink, who started playing downtown in the early seventies, recalls that the Lower Broadway scene was "like New Orleans, Bourbon Streetish. There were actually more tourists than there were what I call 'lovers, muggers, and thieves,' but it was a little dangerous. And then when it started thinning out you noticed more of those people, and the media and the police were really hard on this street."

The Ryman had made Lower Broadway visible, and that visibility became part of the street's burden in the 1980s. One visitor to the city described it as what Bedford Falls would have looked like had it not been for the George Bailey character played by Jimmy Stewart in the film *It's a Wonderful Life*. A few people such as the folklorist Bob Fulcher, who was managing a folklore project in the city in the early eighties, saw it as a cultural resource. In a guide for the American Folklore Society, which met in Nashville in 1983, Fulcher compared Broadway's significance to that of Beale Street in Memphis and Bourbon Street in New Orleans. The Broadway district, he wrote, was populated by some "Opry survivors" joined nightly "by a never-ending flow of transient musicians, blue-collar tourists from the northern-central industrial states, hookers, second-rate players, winos, enlightened European visitors, bikers, and locals devoted to sleaze, beer, and music."

The center of the post-Opry street was the Merchants Hotel at the corner of Fourth Avenue and Broadway. The Merchants dated from the nineteenth century, but by the 1970s it had become a haven for prostitutes and the poor. Robert Moore, who managed the bar in the hotel, built a bandstand and helped make music central there. The street was one long party, and the party often started at the Merchants. Celinda Pink recalled playing there from noon to two in the morning some days and following the party from bar to bar on others. Most of the bars had music, and the rule of the street was that anyone, no matter how talented, could get up and play.

There were street characters galore—Little Bit, Leather Lady, Alley O'Malley, Big Tag, Scooter, and the Incredible Hulk—and enough hype to suggest a nether world where all of the spin put out by the music industry lived on in slightly tortured form. "What they don't know around here they make up," Tabor says, "and what they do know they lie about." Many of the street's characters lived in the cheap hotels that rimmed the area.

Broadway Mae, who lived in the Merchants, had come to Nashville from Mississippi for a goiter operation at Vanderbilt University Hospital and decided to stay on and become a star. Long past the age of being discovered, and cursed with a raspy voice, Mae was undeterred and achieved fame of a sort on the street by singing so badly that she became a novelty. Nightly she went from club to club singing her short repertory of songs—"All Around the Water Tank," "You Are My Sunshine," and "Your Cheating Heart." Some of the bar owners bankrolled a record to sell when she sang and began to advertise her appearances. Lois Shepherd remembered her as a "classy lady" with

a bit of "Delta Dawn" about her, a "sweet, innocent woman-child" who "went out to play big-time singing star" in the carnival on Broadway.

Russell the Hustler presented himself as a con man. His favorite hustle, according to Bob Fulcher, was to give his opponent a four-ball lead in a game of eight ball. "I always win by one ball." Russell was too friendly to be a true hustler, Fulcher said, but he was a student of con games and could talk you through a few for a bottle of beer. Lois Shepherd remembered Russell for his kindness to his companion, a woman known on the street as Bonnie Parker. The two lived together for a time in the Sam Davis Hotel, where Bonnie was employed as a maid. Russell worked in the kitchen at the Hyatt Regency (now the Sheraton), and after work he often brought food, "the rejects," Lois said, to share with Bonnie. "They would take their piece of steak and a potato or two to the Dee-Man's Den, where they would feast while John Shepherd did his five-to-nine show." Russell eventually left town to care for a sick relative. Bonnie developed cancer and lived back and forth between the Mission and General Hospital, Lois said. "She started spending more time on Broadway. Say When II was her favorite place. But with Russell gone, her light just went out. We heard about her death too late to attend her services. She died at the camp of some friends near the Shelby Street Bridge."

The street's problems were complicated by the many homeless people who roamed downtown in increasing numbers. There had been a few homeless people on the street for some time. Tootsie allowed one of them, a man people remember as City View, to sleep on her roof at night. When the cheap hotels—the Ross on Fourth, the Sam Davis on Commerce, the Merchants on Broadway, and others—closed their doors, a lot of marginal people were dumped onto the streets. Lower Broadway, a thoroughfare that connected the mission with the homeless communities under the Shelby Street Bridge, became synonymous with the urban problems that troubled the vacated central cities of the nation.

The 1980s were a difficult time for Lower Broadway. "They let this get so bad with drugs and prostitution and what have you," the old-timer Buddy Shupe remembered. "They said Broadway was the roughest place in the world, and it was pretty rough. You could see ten fights over there anytime you walked up the street. They didn't police it." Jule Tabor recalled these as the Dodge City–Skid Row years. "Things were really spastic down here. I got shot three times by one fellow. Another time I got stabbed over in that alley by the Ernest Tubb Record Shop. Stabbed me five times with a pair of scissors before I knew what hit me." And Katherine Moore, who shot a man who came at her with a knife while she was tending bar at the Hitching Post, recalled, "The city more or less said that's Skid Row, and we will turn our back and put our attention elsewhere." Some old-timers such as Mattie Gates, who worked in clubs on or near Broadway for almost fifty years, claimed that the picture of the street as a lawless zone is overdone. "This street has seen days or nights

when there were prostitutes and people bumming, but you know I can't help what these people tell you, I was never afraid to walk these streets by myself back then."

Robert Moore, who managed a string of bars on Broadway, including the Rhinestone Cowboy and Tootsie's, was the informal security of the street. A former bare-knuckle fighter, Moore often was all that stood between the street and lawlessness, Buddy Shupe said. Old-timers remember Moore, now in his seventies, as always fighting. Over the years he also has been one of the street's most public-spirited citizens. He's quick to give a troubled street person a meal and some coffee, and he is usually at the center of the benefits held to raise funds for those sick or facing trouble. Many people have stayed at his house when they were in trouble, and when the Merchants Hotel closed in 1985, a number of the residents moved into his house for a time.

When Nashville's convention center opened on the corner of Broadway and Fifth Avenue in 1987, the policing of the 400 block increased dramatically. The city placed the center's entrance on Commerce and made the Broadway side its backdoor to avoid contact with the street but saturated the area with police nonetheless. Old-timers recall the late 1980s as a time when patrol cars lined the block and police arrested drinkers and employees for a variety of offenses and near-offenses. Celinda Pink remembered that it was hard for her to complete a show during this time because the police so regularly shut down the bars. Katherine Moore, who ran the Turf, recalled that time harshly: "They decided they were going to build a convention center, and they just about ran everybody out of business 'cause by then it was almost so far gone [from a lack of policing] that everyone was in violation. We suffered through a lot of hard times in the [Mayor Bill] Boner period."

By the mid-1990s there wasn't much left of the carnival culture on Lower Broadway. The tips band at the Turf was hot enough to stir up a crowd and dissolve the boundary between the homeless and the tourists, and Celinda Pink still rocked the Music City Lounge some at night. And, as he had been doing for most of three decades, John Shepherd was still drawing a crowd for the five-to-nine shift.

John first came to Nashville in the early 1960s, hoping to make it in the music business, but, intimidated, he went out on the road for ten years. When he returned to Nashville in 1972, he started playing solo at the Dee-Man's Den in the Merchants Hotel building. John played there six or seven days a week for eight years. He struggled to do other projects as well, often on a voice strained from overuse in rooms with too much smoke and too little ventilation. In 1975 he managed to put out a single, "Shackles and Chains," which he sold from the stage. In 1979 he got a break and for six months was the voice on the Miller beer commercial ("If You've Got the Time, We've Got the Beer") before Johnny Paycheck replaced him. He bought the car he still drives, a 1974 Oldsmobile Ninety-Eight, with money from that deal.

After the Dee-Man's Den closed in the early 1980s, John played at most of the spots on the street: Big Daddy Moose's, Wanda and Louie's, Tootsie's, the Wagon Burner, the Rhinestone Cowboy, Tiger's Country Saloon, the Wheel. By the time I heard him, he had been at the Music City Lounge for seven years. John still loves to play and sing, but the years have taken the romance off the business. "I am a day worker. One day at a time. Lois and I are artists in our trade, doing what we do. The only place I see to do it is in a bar where people want to hear me." He has adapted to the life of the street through the years, but it wasn't what he came for. "I came to town to be a singer, not a squaller, and I ended up squalling. Out-shouting the drunks, that's what I do. But I came here to be a singer like Bing Crosby or Jim Reeves or Marty Robbins or Andy Williams. There are so few in the business who sing pretty."

Many days the Music City Lounge looked like a last-stop saloon. John's crowd was made up of day workers, homeless people, and a few longtime regulars. Occasionally a friend from years past would return to stay the shift. And sometimes an adventurous tourist would stray in and stay awhile. But there was a lot to ignore if you weren't a regular. There was that sign in the window that told you to leave your pack outside. On any given day there could be some midnight howling before the sun went down or an edgy drunk looking for an argument. And near the end, after the tornado in 1998, there was roof damage and a makeshift porch over the sidewalk to protect pedestrians from falling bricks. You could dress up the Music City Lounge, though. Mama Jo Eaton, who operated the bar, was married there one Sunday, and the place was transformed. She got out of a horse-drawn carriage and walked past the bar to meet her beloved and exchange vows in front of an altar of flowers and candles so pretty that you forgot they were hiding a pool table. Beverly, the bartender at Legends across the street, performed the ceremony and united Mama Jo and her new husband in the "everlasting name of Jesus."

Most days I would sit with Lois Shepherd until the smoke drove me out. I always thought John deserved better. He could sing a soft, sweet country ballad with the best singers. Over the years he had taught himself to be an entertainer as well. He knew a huge number of songs and could sing them on demand as if that was just the song he had been wanting to sing all along. He could handle hecklers and calm down drunks. And if there was somebody in the crowd who wanted to sing a song, he could step aside with grace or play backup. Lois always joined John on stage for a few songs, including some of her own, and they had great charm together. The crowds were better some days than others, but John and Lois were always there no matter what, and they gathered around them a core group who loved them and their songs. At the Music City Lounge, I sat with men and women who don't buy many CDs or go to many stadium shows or even listen to the radio much anymore. But they came there with their ways of feeling, which a lifetime

had given them, and their feelings that moment, which the day had given them. And we were all a little more alive because of John and Lois. "The people I play for can't afford to go to a shrink and get a prescription for tranquilizers, so they come in and drink their tranquilizers. The music helps them feel as blue as they are sometimes and forget how blue they are other times."

Country songs, perhaps because they are so full of stories, sometimes seem to speak our own feelings. Gary Bennett of the band BR549 says the songs connect us to our lives in ways that plain speech can't. "There was this one guy who used to come in here when I was playing as a single. He would request this song his little girls used to sing before he got drunk and left the family ten years ago or whatever had happened to him. And he would say 'Can you do that song?' and then he would sit there and bawl. And you would think, 'Why does this guy want to put himself through that?' Well, he's taking himself back to this one little place, and he can't do that if you walk up to him and ask, 'Hey, how was it ten years ago when you were married and had a couple of little kids?'" Country music, Bennett believes, grew out of the experience of poor people telling their stories. It comes originally from a time when "life was just a lot sadder and less controllable, because of a lack of money, doctors, what have you. The music started with some old broken-hearted woman writing a song about her little boy that died and singing it out on the porch just for herself." That music has always been wherever you find poor people, Bennett says. On some days John's crowd at the Music City Lounge seemed to be the poorest of the poor, but they had their songs of the heart, and the music was live and full of power.

Looking for Broadway, Looking for Nashville

The following story is told and retold on Broadway. A group of tourists has been in town a few days. They've gone to the Opry, Hall of Fame, Music Row, and the Wildhorse Saloon, but something has been missing. Somehow, Nashville has disappointed them. And then the night before they are to leave, they take a stroll down Broadway and find Robert's Western World, a down-home honky-tonk where the music plays nonstop from ten in the morning until two in the morning. At last they are satisfied. "This is country music," they profess. "This is what I came for."

Nashville has made itself into Music City, and so fans come to touch the music, at least some of them believing the experience here should be more compelling and fulfilling than anywhere. But country music lacks the singularity it enjoyed in the 1940s and 1950s, when Nashville and the genre became wedded together and the Ryman was indeed the "mother church" of country music and the Opry was guaranteed to deliver the ultimate country music experience. Today's tourists may be fans of "new country," like the thousands who gather on New Year's Eve at the Gaylord Center to hear Tim McGraw or Kenny Chesney.

Or, like my three aunts, all in their seventies, they could be coming to hear "classic country," the stars of their youth who are still the Opry's focus. "I want to hear Porter Wagoner and Bill Anderson," Aunt Paris proclaimed. Or they could be coming, as some friends of mine from Wisconsin did not long ago, just to hear Americana artists Kevin Welch and Dave Olney sing songs forged at the boundary of folk and country. There are enough versions of country music to make relativists of us all. Some tourists, as in the stories from Robert's Western World, still find their country music experience on Broadway. The street is going through another change, though, and these days the music people have to fight for space with conventioneers and football fans.

Broadway is in the final stages of a metamorphosis that began in the 1990s. On one end a string of tourist-oriented businesses along the riverfront turned the corner with a Hard Rock Cafe and pointed theme restaurant developers up Broadway. Planet Hollywood followed, pushing the ethos of slick, nationally oriented chain marketing toward the 400 block, and a NASCAR Cafe claimed a spot between the two. At the other end of the street, the Ryman Auditorium reopened in 1994, and a couple of years later the Gaylord Entertainment Center followed. A new Hilton suite hotel on Fifth Avenue followed in 2000, and the Country Music Hall of Fame opened a year later just to the South. The new development, along with some pressure from the city on the landlords, drove out the pornography and shrank the hard-time honky-tonks, but natural dis-

aster speeded up the process. In April 1998 a tornado swept down Broadway and badly damaged the buildings that housed both the Music City Lounge and the Turf, the last of the rough and rowdy joints. The Turf's building fell in during attempts to repair it, and the Music City Lounge struggled on a few months before closing for good in the winter of 1999.

When the NFL Titans moved into the new coliseum just across the river in 2000, the 400 block of Lower Broadway appeared to be developing a new identity as the party strip connecting the coliseum and the Gaylord Arena. The street has retained some local flavor after both the NASCAR Cafe and Planet Hollywood failed in 2001. And its country music connection has been enhanced by the new Hall of Fame and the refurbished Ryman, now home to the Opry from November to March. Still, if you walk down Broadway these days, many of the people you meet don't know anything about country music. They are heading for a hockey game or an AC/DC concert at the Gaylord Center, or, if it's a Sunday in the fall, they have parked downtown and are heading across the river for the football game.

All of the new development around Broadway has the look of the corporate world—Nashville as a New South destination, similar to Atlanta and Charlotte. It's slick, digitalized, and pop, like the country music that fills the radio play lists. It's been a time of great possibility for Nashville, and the city has basked in its newfound glory as a major-league city—not the Athens of the South or Music City but

the home of the NFL Titans and the NHL Predators. Surrounded by all this corporate possibility, the 400 block of Broadway seems almost quaint. More than ever, the street seems to be just this little block out of scale with everything around it, a throwback to some lost time. That's why the street is able to provide the "this is it" experience for some tourists.

In the mid-1990s Broadway became a hot spot when Robert's Western World and its house band, BR549, were delivering a "this is country music" experience four nights a week from nine in the evening until two in the morning. Robert's Western World sits in the middle of the 400 block, three doors down from Tootsie's. Moore opened it as Robert's Western Wear in the early 1990s, but the clothing store wasn't doing as well as he wanted so he started to change it over into a beer bar a piece at a time. The honky-tonk started to take off in the summer of 1994, when BR549, a young band with a lot of energy, began to play revved-up versions of classic country. Up the street at Tootsie's, Greg Garing was singing a lot of the old songs in a way that made many see and hear Hank Williams. Between the two, Broadway was finding a way to make "singing the old hits" more contemporary and creative. Moore had a sense about his young band and early on put up a sign that is still there proclaiming Robert's the home of BR549.

When the band started to draw a crowd, people found a room that was part honky-tonk, part clothing store. Everything looked makeshift in the beginning—Robert's looked like just that morning it had been trans-formed into a nightclub—and that was part of the charm. Garing and BR549 started to attract the young and hip, and before long music industry people and celebrities came as well.

The Broadway scene was part of a larger, lively alternative country scene that arose in Nashville in the mid-1990s and extended well beyond the boundary of Broadway. In Nashville, as elsewhere, the scene was organized around artists who were recording on independent labels and wedding country to rock beats or revisiting older styles of country music. When Bloodshot Records sampled this music in a volume of its "insurgent country" series in 1996, it took the album name from what was occurring on Broadway and called it *Nashville: The Other Side of the Alley.* Greg Garing was on that CD, as were Paul Burch, R. B. Morris, and the Calvins. All these performers played on Broadway and were part of a revival of spirit that for a brief time produced fantasies of Broadway as a new creative center where musicians and songwriters could jam and write as in the old days.

Garing pulled in Lucinda Williams, who had newly arrived in town and was working up the songs that would become her breakthrough album, *Car Wheels on a Gravel Road.* She, in turn, brought newcomers such as the Knoxville poet R. B. Morris and the Midwest blues legend Bo Ramsey to Broadway. Morris remembered that he performed "Roy," a song that appeared on the *Across the Alley* CD, for the first time in Nashville at one of Garing's shows. Lucinda was an important part of the Nashville live music scene at this time. She played in the local clubs, and when

she wasn't playing, she could often be found at the shows of others. She promoted artists to Nashville audiences and would often sing a song or two at friends' shows.

There were other factors that brought vitality to the Nashville live music scene. Steve Earle, who had returned from a short stay in prison, put out a number of fine albums and often played in the clubs when he was in town. Gillian Welch and Buddy and Julie Miller were just emerging as strong acts with followings. A diverse group of artists that included Amy Rigby, Duane Jarvis, Kevin Gordon, Malcolm Holcombe, Tim Carroll, Gwil Owen, Lonesome Bob, and the Del McCoury Band had moved to Nashville and were playing in the clubs as well. And the city had a large group of established singers who could connect to the new scene and amplify its significance, including Emmylou Harris, Guy Clark, John Prine, Steve Young, Nanci Griffith, Dave Olney, Kevin Welch, Kieran Kane, Billy Joe Shaver, Rosie Flores, and Townes Van Zandt (who has since died). A lot of club shows featured touring alternative artists such as Son Volt, Whiskeytown, the Jayhawks, Wilco, Dave Alvin, Ray Wylie Hubbard, Freakwater, Kelly Willis, and Richard Buckner. The scene wasn't happening just across the alley, but Broadway was its most visible manifestation.

As time went on, Robert's became more and more honky-tonk, and BR549 more polished. A dance floor and a balcony, as well as more booths, were installed, but the vestiges of Western Wear remained in the row of boots that line the left wall and became the club's signature. When Garing decided to leave Nashville for the rock-and-

roll life in New York, he left the Broadway spotlight to BR549. It had been a long time since the street had produced such a success story as BR549. And this one seemed to be happening in the most unusual of places: a boot store turned honky-tonk.

Robert's played with people's expectations about Broadway, country music, and Nashville itself. In a town where every move in the music business is cultivated for effect, Robert's and BR549 seemed to be happening spontaneously. To the band it was like a fantasy. "We felt like we were in a movie about a band that went to Nashville and had this great Cinderella story happen," Gary Bennett remembered. The press loved Robert's, and word of the band spread from Nashville to the national media. Peter Applebombe, a *New York Times* writer, wrote in *Dixie Rising* (Times Books, 1996), "I would have been as interested in hearing cats screeching at night as listening to Ferlin Husky or Webb Pierce, but it struck me as just about the coolest place I'd ever been." For a time the club made some fans fantasize about a fuller live music scene on Broadway that would appeal to both locals and tourists.

BR549 and Robert's recalled an earlier time and style of honky-tonkying without being that. They connected to the Broadway myths while being contemporary at the same time. The band was both reverential toward country music and able to do a campy send-up of it, one minute playing a heart-aching version of Hank Williams and the next a sit-com parody, "Me and Opie Down by the Duck Pond." Robert's was a world that could contain all the contradic-

tions. When the band signed with Arista, stories that only yesterday had been so unexpected—like the one about country star John Michael Montgomery paying Chuck Mead six hundred dollars in twenty-five-dollar tips for every Hank Williams song he knew—became a part of the band's press kit and were worn thin as they were told in every town where the band played. The club lived on in the stage patter, and the band recorded a live album at Robert's. But although BR549 has recorded three studio albums and toured widely, it has never had a breakthrough hit. Eventually Gary Bennett and Jay McDowell left the band, and two replacements were added. Before all that happened, though, the guys played the Opry a number of times. During one of these performances they gave up some of their time for one of their Broadway friends, allowing John Shepherd to realize a lifelong dream by playing the Grand Ole Opry.

When BR549 left, the band took the excitement of the Broadway music scene with it. Tourism reigns on Lower Broadway these days. The city planners have decided to make Broadway central to their view of the country music experience. Nashville is a three-stop town now for tourists: the Ryman and the Country Music Hall of Fame downtown, Music Row in midtown, and the Opry House and the new Opry Mills mall in the eastern suburbs. On Broadway there is a new barbecue place where the Turf and the Music City Lounge stood. Robert sold his Western World to Jesse Lee Jones, a young man from Brazil who fronts a band called Brazilbilly, which has been playing there since

BR549 left. John Shepherd, who in 2002 celebrated thirty years on Broadway, now plays the afternoon shift there most days. Robert Moore moved a couple of doors down the street to a gift shop in the old Friedman's pawn shop building. Before long he transformed it into a honky-tonk, with electric guitars hanging where the boots stand at Robert's. Moore, the main force on the street in the 1980s and 1990s, sold his last honky-tonk to Ruble Sanderson, who also owns the Legends Corner, the gift shop next door, and the Stage, a club where the old Adult World stood. Sanderson and Steve Smith of Tootsie's represent the new business style of the street. In the old days the denizens of the street often became its businessmen, but Smith and Sanderson came to Broadway for the business.

Business looks good on Broadway, but all of the development doesn't make finding the symbolic center of country music any easier. Still, as Neil Strauss, a writer for *The New York Times*, found out in 1999 when he came to Nashville, it's tempting to look. Strauss wrote about the old and new Nashville, but he could not resist writing a "this is country music" story before he left town.

For the last five months I have been writing from Nashville, searching for the heart of Music City. I have gone to the mansions of country stars, the shotgun shacks of forgotten singers, the offices of music executives, the dressing rooms of the *Grand Ole Opry* and the basements where the wax figures of yesterday's country stars lay vandalized. And then one day I found it: the soul of a city that residents often say lacks one.

It was at a hotel and bar: a hotel where the hopeful go to fulfill their dreams, a bar where the jaded go to forget they ever had dreams.

Like others before him, Strauss found his "this is country music" story in a honky-tonk, one just off Music Row. He was too self-conscious to be a pilgrim, but he wanted to present a symbolic center even if he really didn't believe in it. It is a legacy, I suppose, of a time when there was such a center and you could go to the Opry on Saturday night to find it. That's why those old photographs of the Ryman are so powerful. Those fans who came to the Opry weren't mere tourists who hit Nashville this year and maybe Charleston next summer and Disney World the following year. They were pilgrims, and their faces were full of longing to be inside this holy spot they had come some distance to witness.

"Music City" is a phrase dreamed up by a WSM radio announcer that became mostly a marketing concept, but the city is filled with music nonetheless, and it is what makes Nashville unique and not just another New South town. The music has lived on Broadway. It has been heading for the top and going nowhere, but it touched down there and marked the place and its people. Bill Rouda got in the middle of the music when it was full of passion and no one knew what was going to happen next. In the best of these photographs, you can see the way the music felt. And even when you can't, you can feel the longing for the music. "Cowboy, my heart's full of songs and they cry to be written," Lois Shepherd writes in one of her tunes.

Broadway's been a street where songwriters have raised some hell and cried their hearts out, where a lot of lost, lonely, poor people found a song to get them through the night, and where a group of exciting young musicians sought to find the creative link between the contemporary and the traditional. The city hasn't always been sure about how it felt about Broadway, and it seems happier with the name "Hillbilly Highway" that the planners have now bestowed on the street than it ever was with a street full of hillbillies. But if we are lucky, amid the football fans, conventioneers, and tourists, someone will remember the songs and how they made the street, in good times and bad. Gary Bennett believes that as long as there are poor people there will always be country music and that as long as there is some kid in Kansas or Washington who has the country music dream there will always be Broadway. That's a romantic idea, but I hope he's right. And if he's not, we will be all the more fortunate to have these photographs of a time when it was possible to wander Broadway and believe in its song.

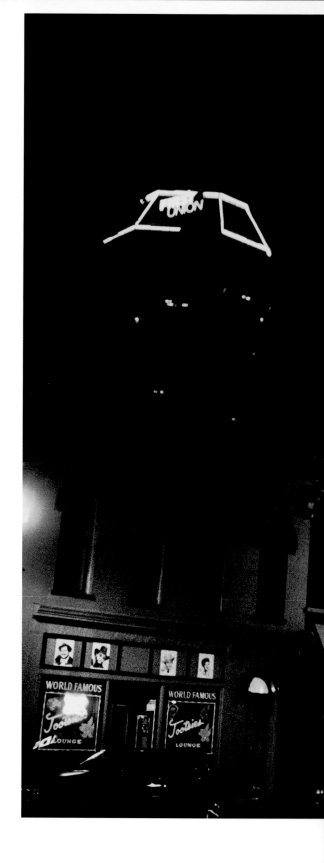

The north side of the 400 block of Lower Broadway, an alley away from the Ryman Auditorium, appears tiny next to downtown Nashville's new office buildings.

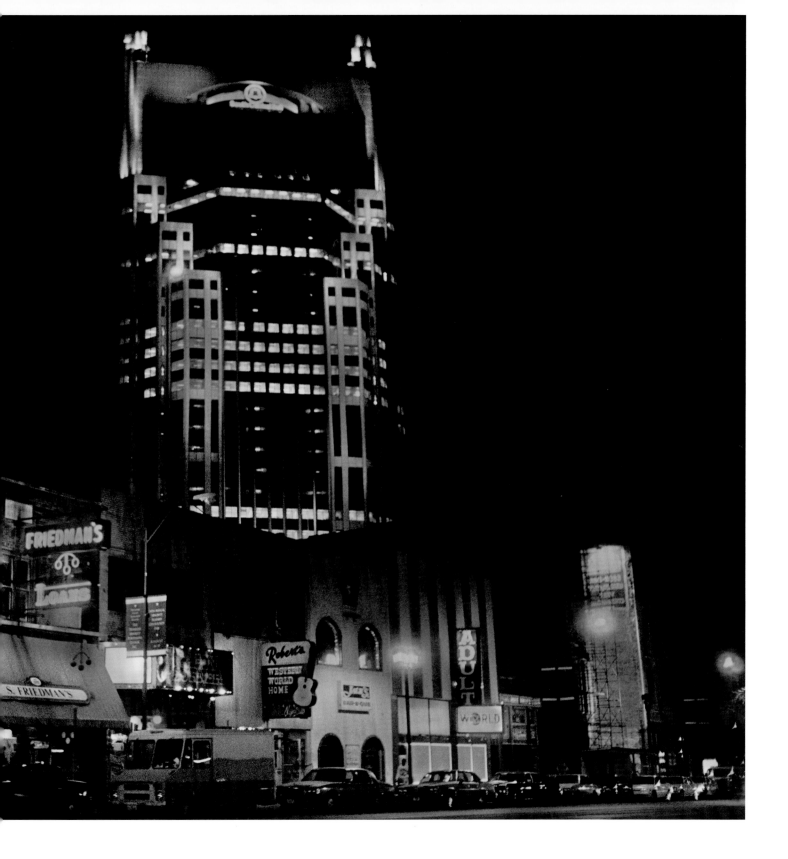

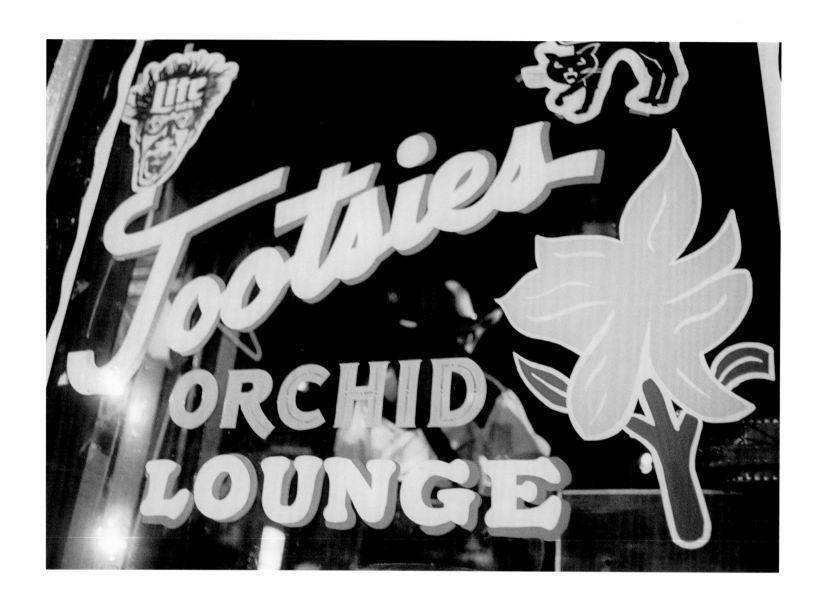

Only a window separates passersby from the music at Tootsie's Orchid Lounge.

Shadows play on the stage.

Singers come and go on Broadway. Truckerlady Tina sings the hits at Tootsie's Orchid Lounge.

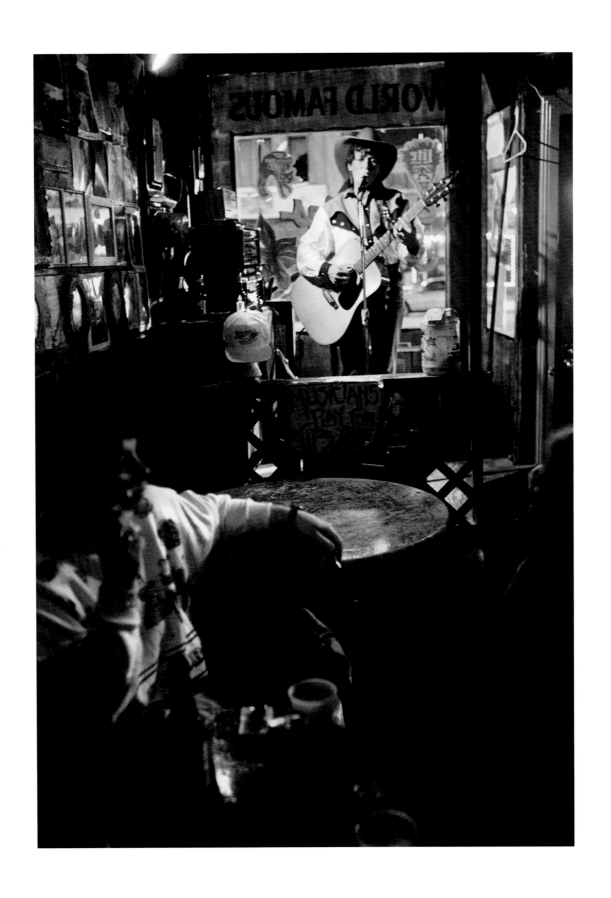

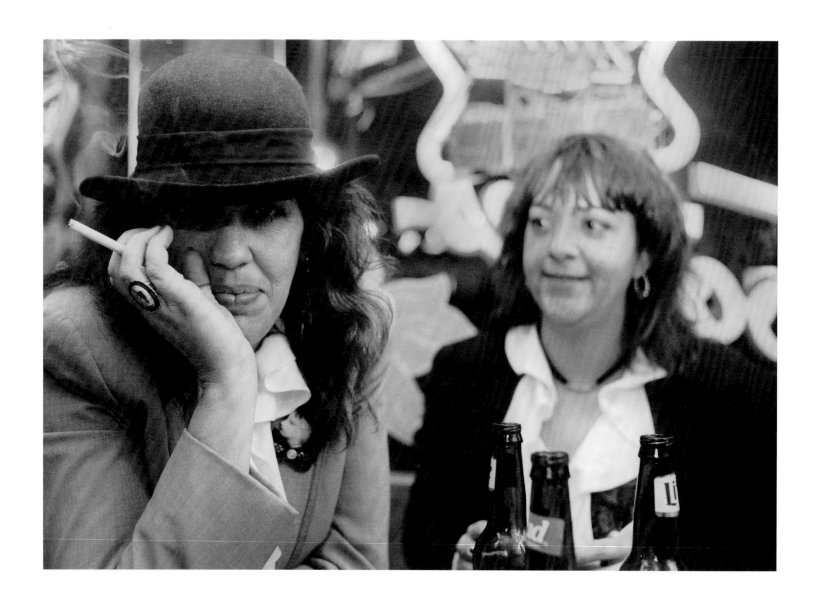

The blues singer Celinda Pink and an admiring fan share a table at Tootsie's.

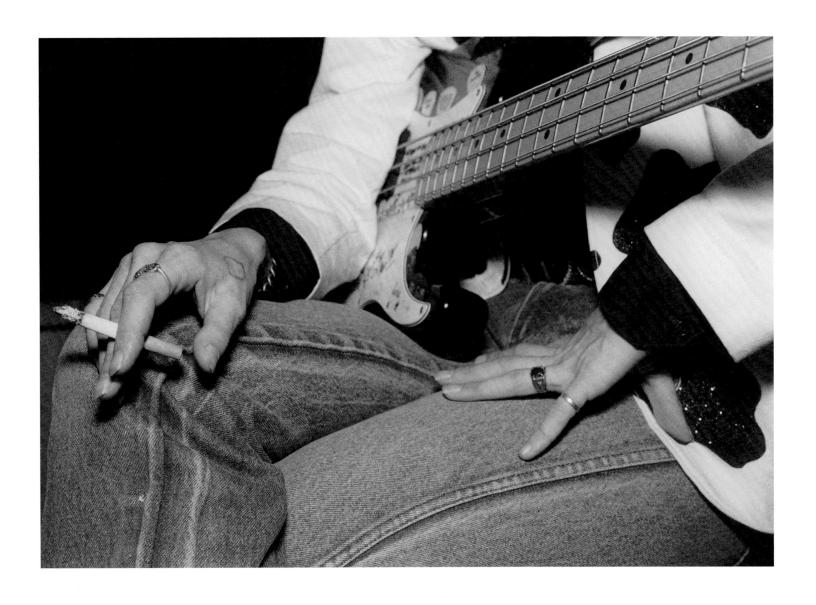

The bass player takes a smoke.

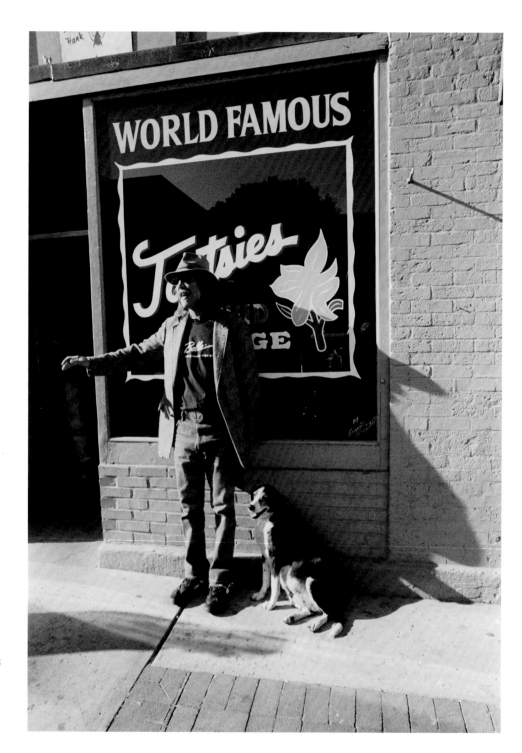

Street poet Jule Tabor, with his dog, Huzzie, calls in the crowds at Tootsie's.

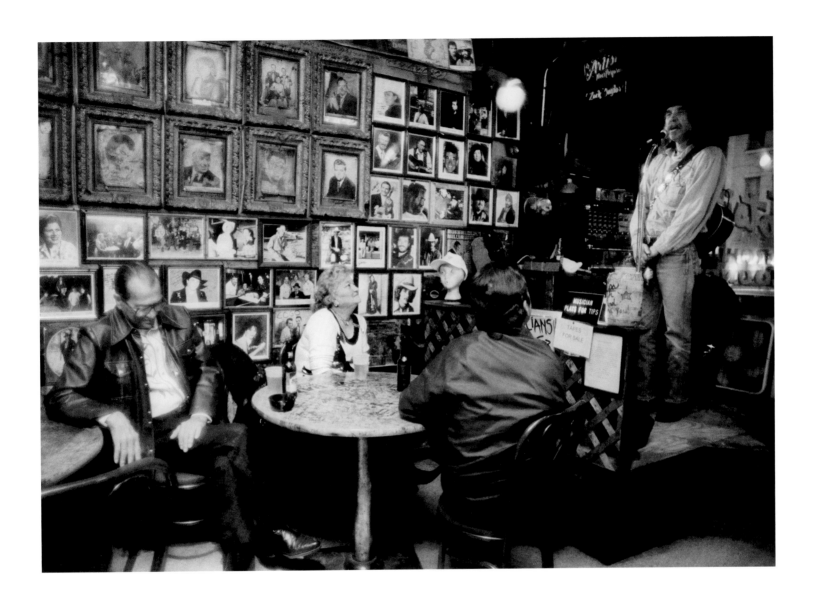

Jule recites a poem at Tootsie's as old-timers Wanda and Louie Lohman listen intently.

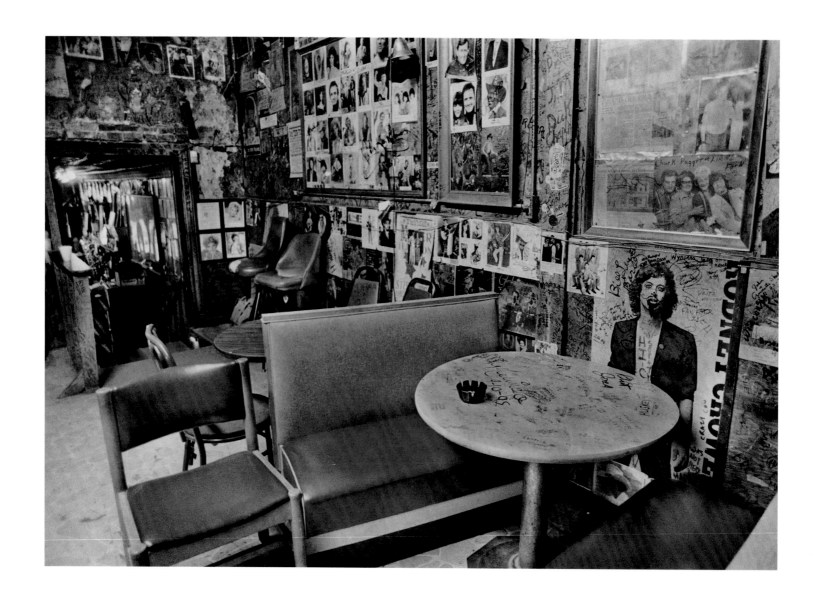

The back room at Tootsie's was the gathering place in the 1960s for many country music greats waiting to go onstage at the Grand Ole Opry.

The wear and tear of the years has become part of the decor of Tootsie's back stage, shown here before reroofing.

A Tootsie's bartender dresses up as Dolly for Halloween.

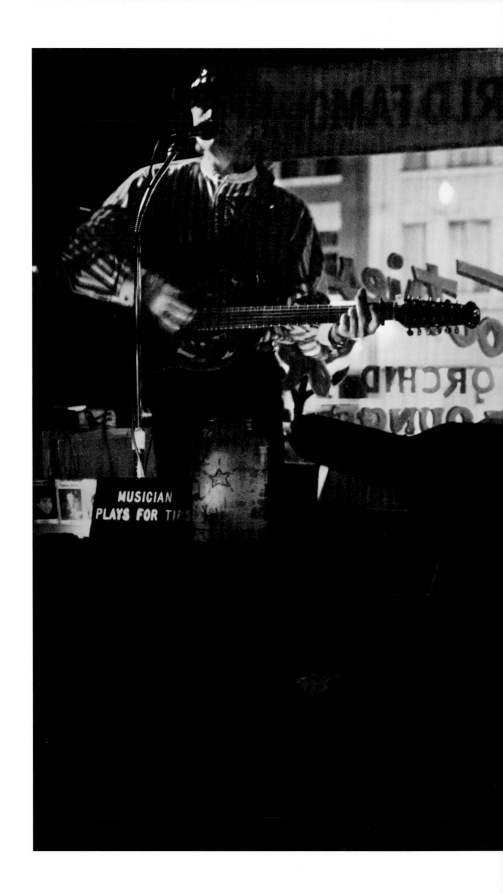

The view from the bar at Tootsie's gives a glimpse
into life on the street.

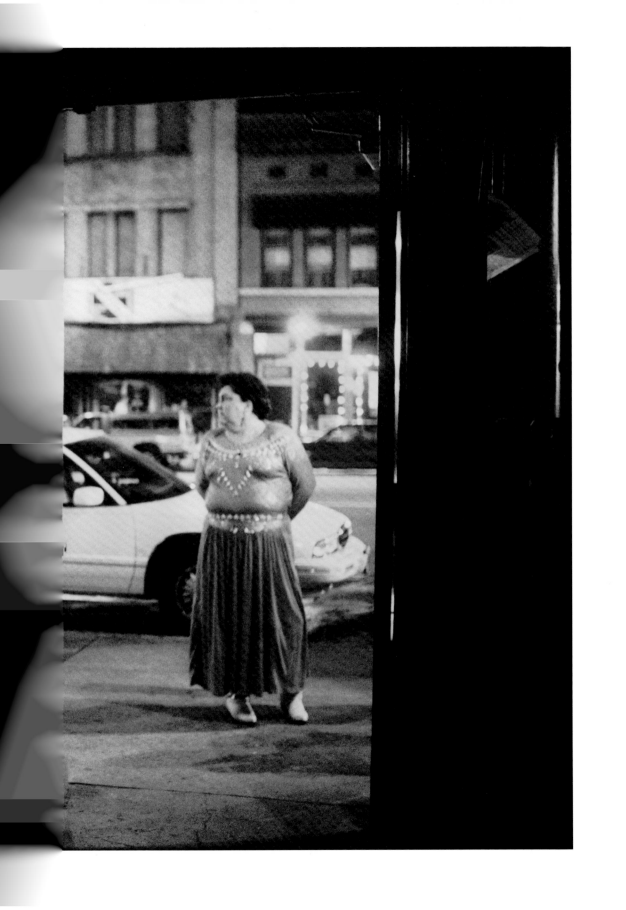

A policeman sits astride his motorcycle on the north side of Broadway.

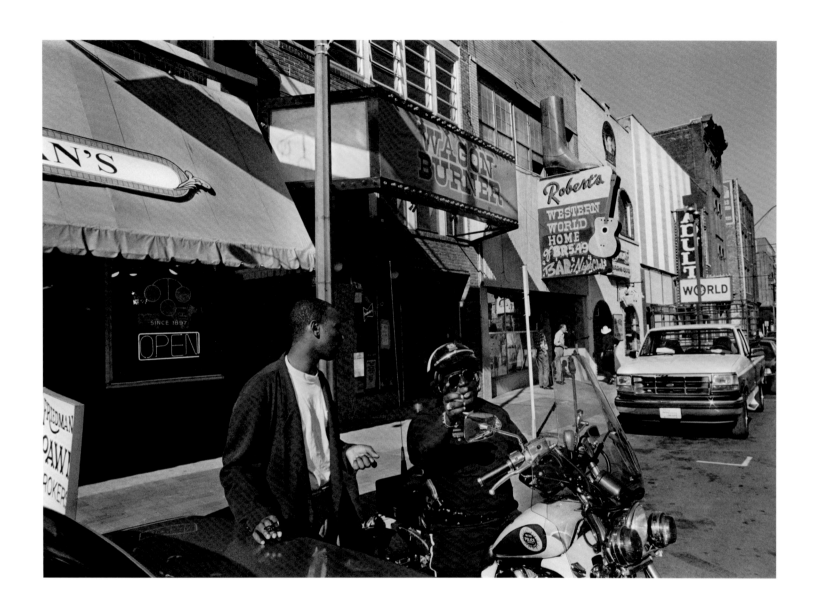

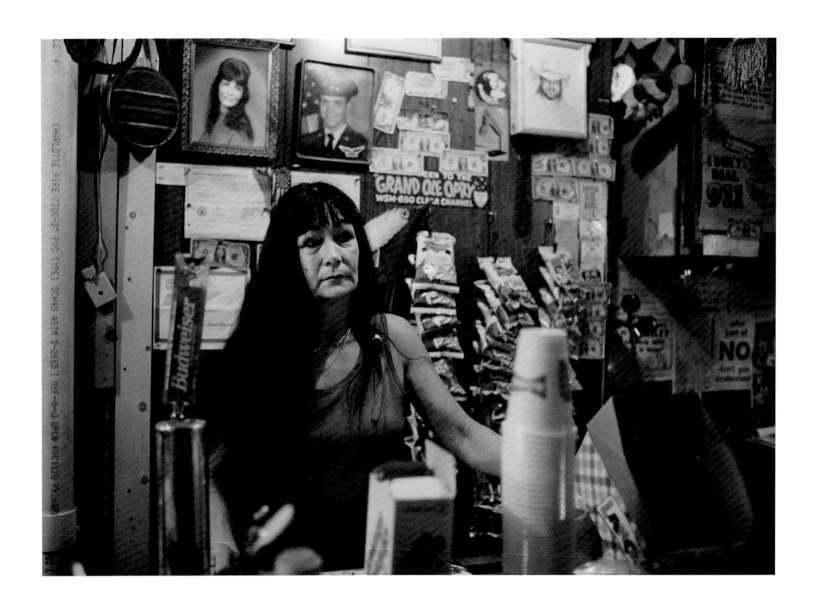

Miss Pat, proprietor of the Wagon Burner, stands among mementos and potato chips.

36

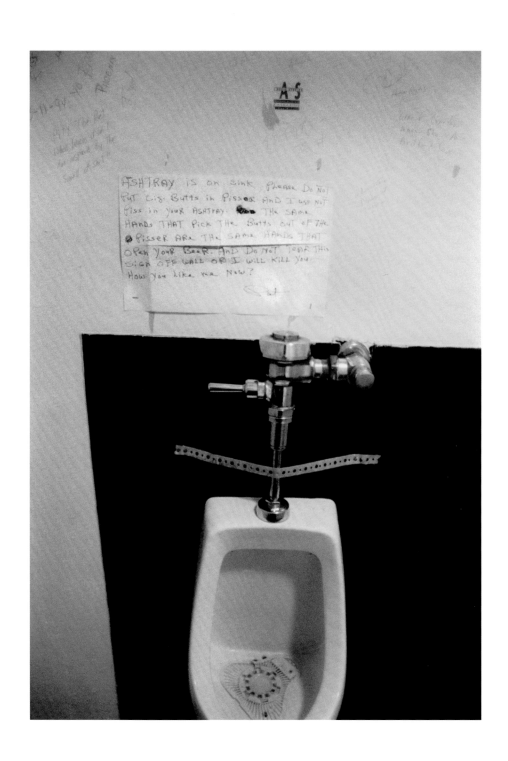

A note from Miss Pat, attached to the wall of the men's room, lays down the rules.

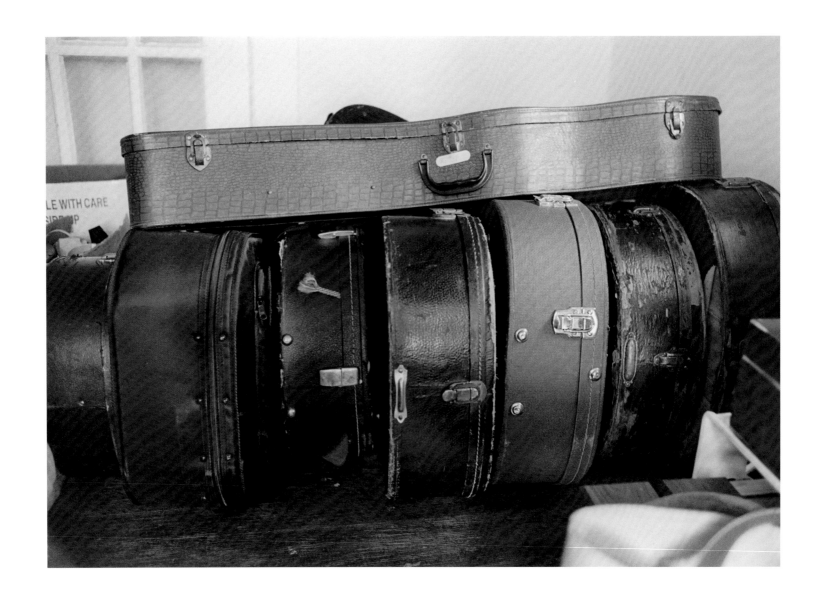

Guitar cases are piled high in the small bars.

The band takes a break.

A musician at the Wagon Burner counts the tips.

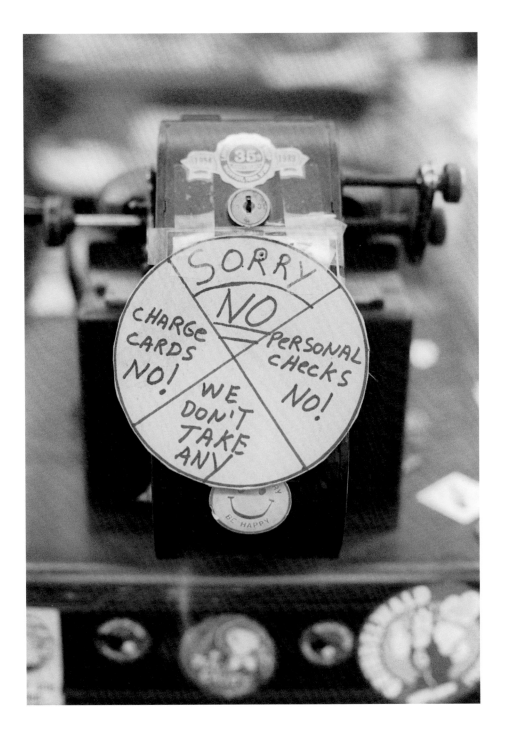

In the early 1990s Broadway
was still a cash-only street.

The Wagon Burner's back stairs lead to the alley and the Ryman Auditorium.

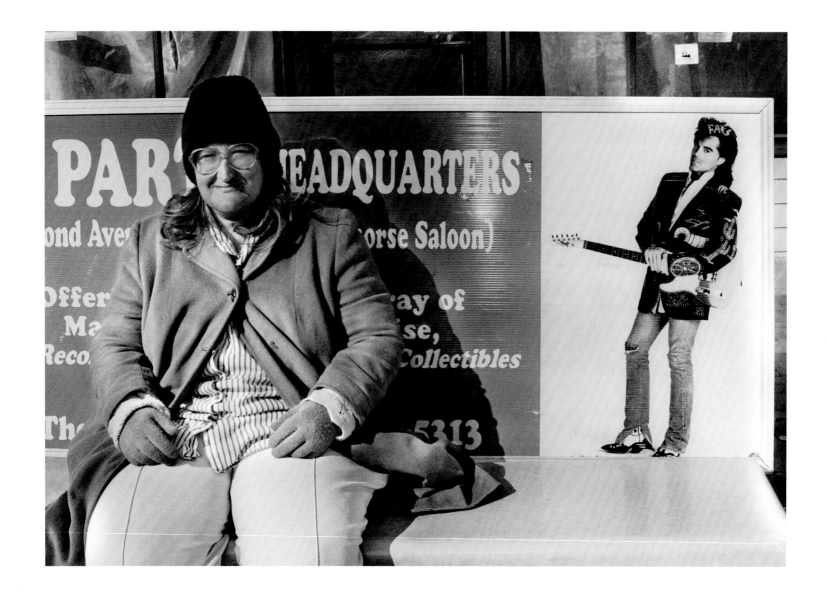

A homeless woman waits for a bus on Lower Broadway.

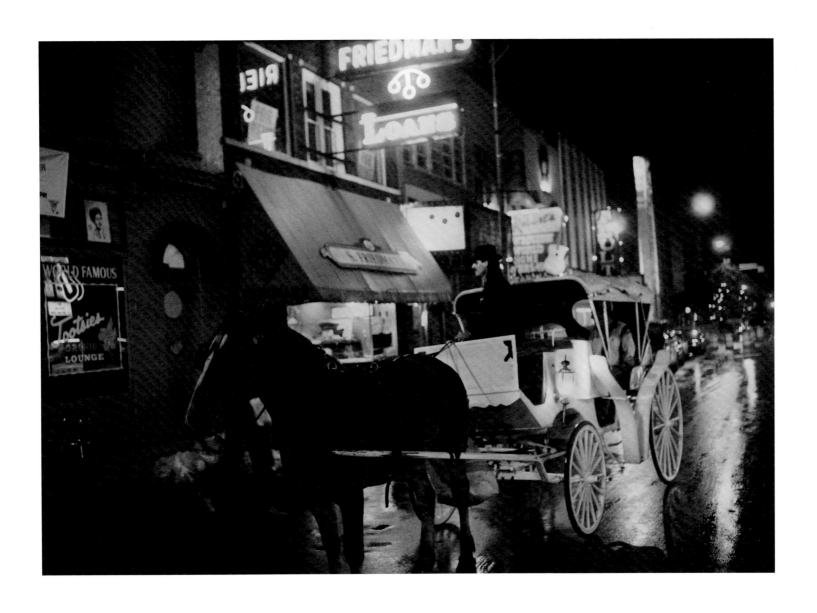

A horse-drawn carriage brings in the tourists.

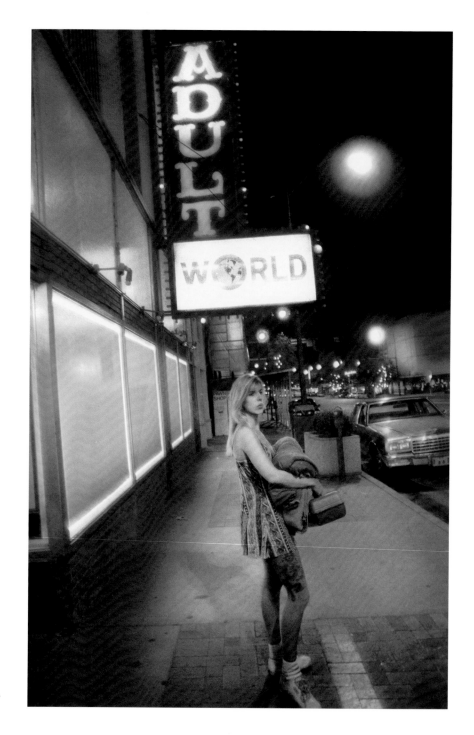

Outside Adult World, the last of the pornography stores, a woman looks for action.

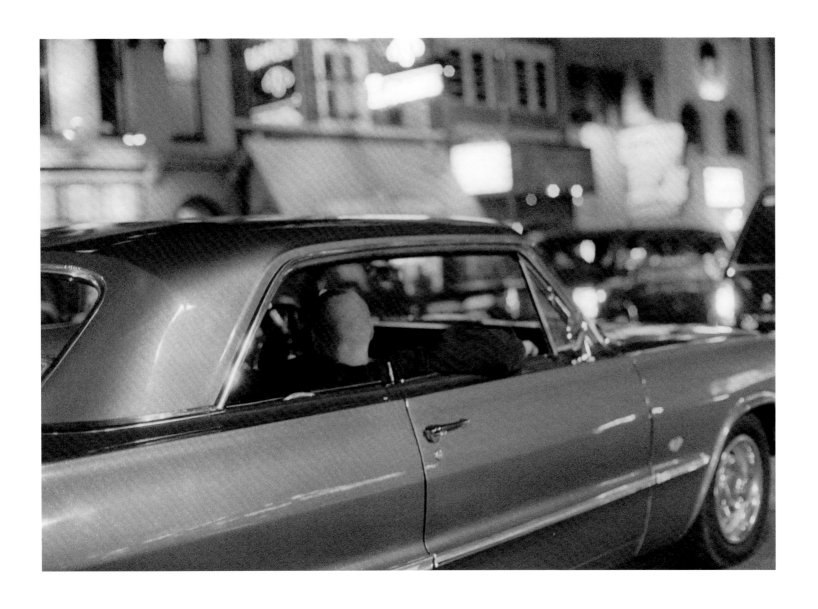

For the young, Broadway is a street to cruise.

Huzzie rests on the dashboard of Jule Tabor's van, a
view of the south side of Broadway behind her.

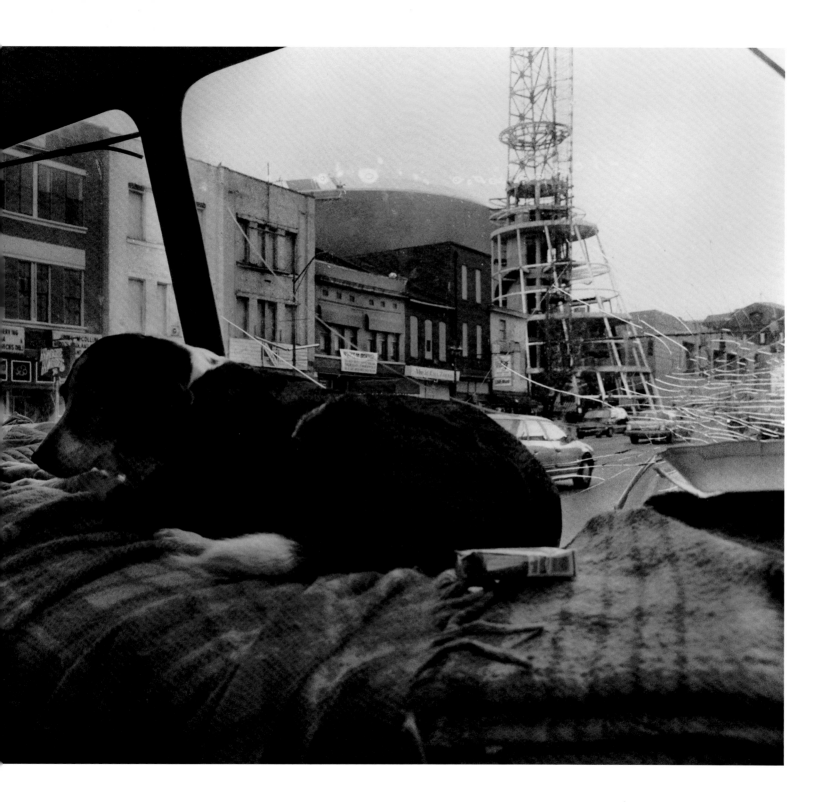

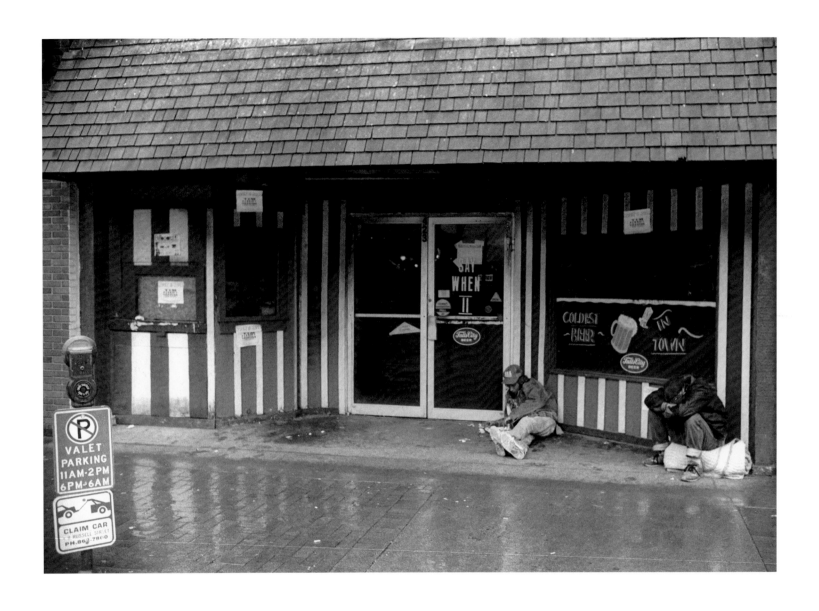

Say When II, closed by the mid-1990s, was one
of the hard-core bars a decade earlier.

50

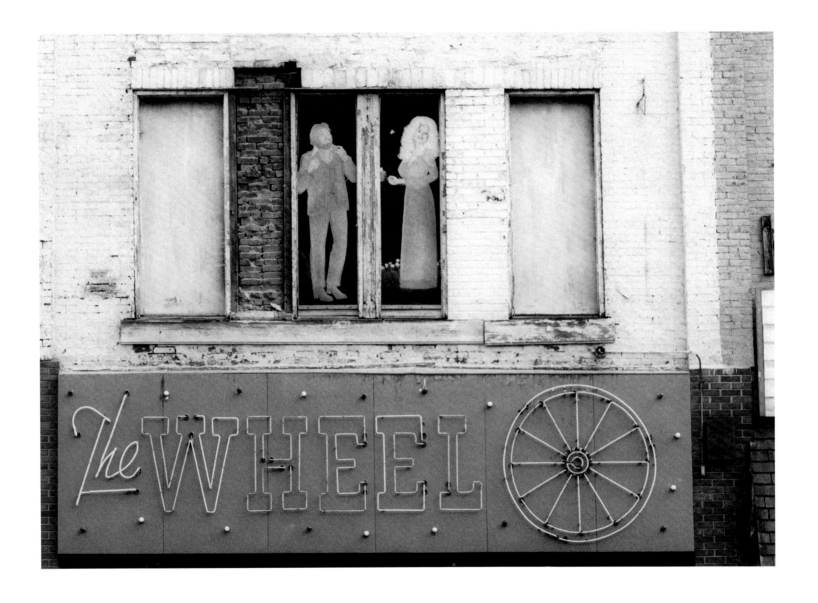

The Wheel, which began life as a bar (Willie Nelson's first wife worked here), had become a pornography store by the 1980s and was empty by the early 1990s.

A transient smokes outside the hard-rocking Turf bar on the south side of Lower Broadway.

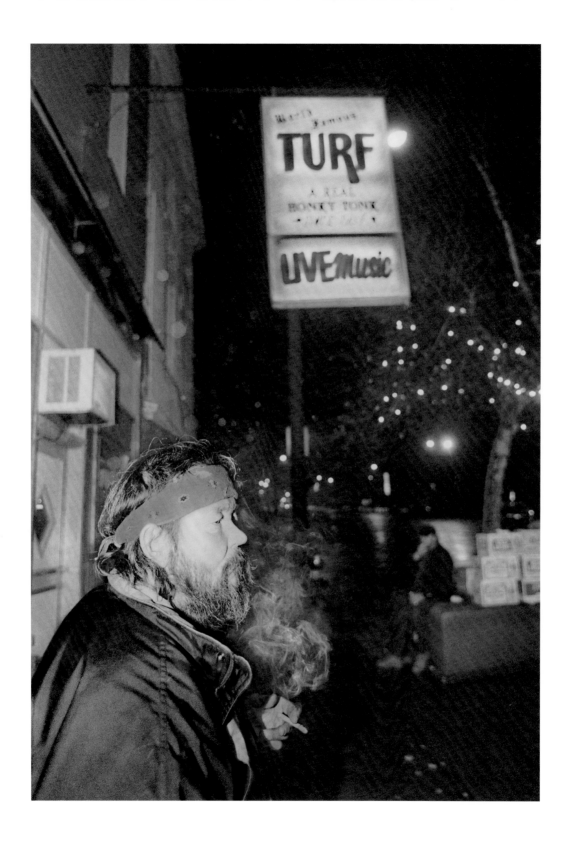

The Turf's bouncer keeps his eye on
the street as the band plays on.

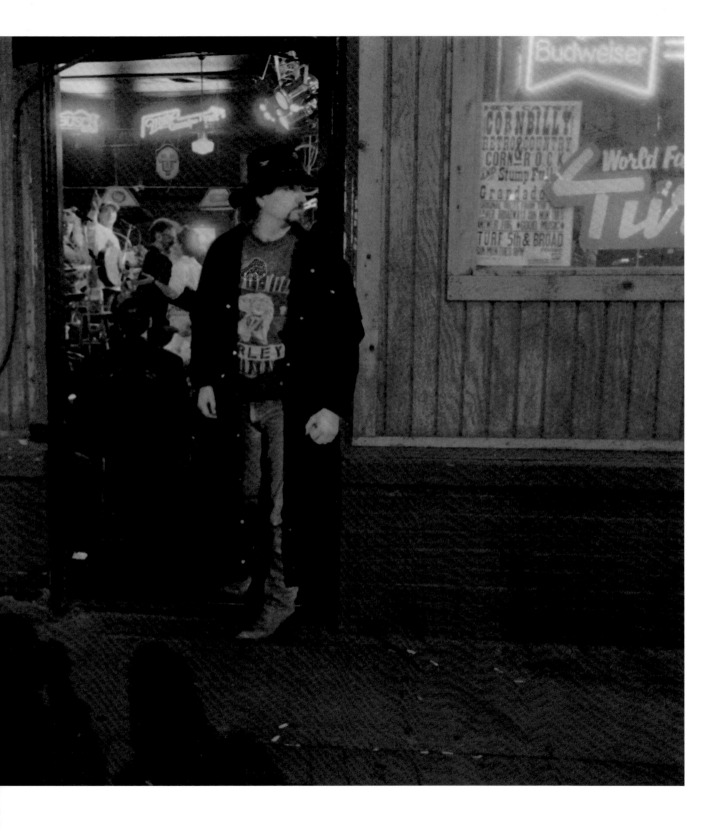

The bass player sings out.

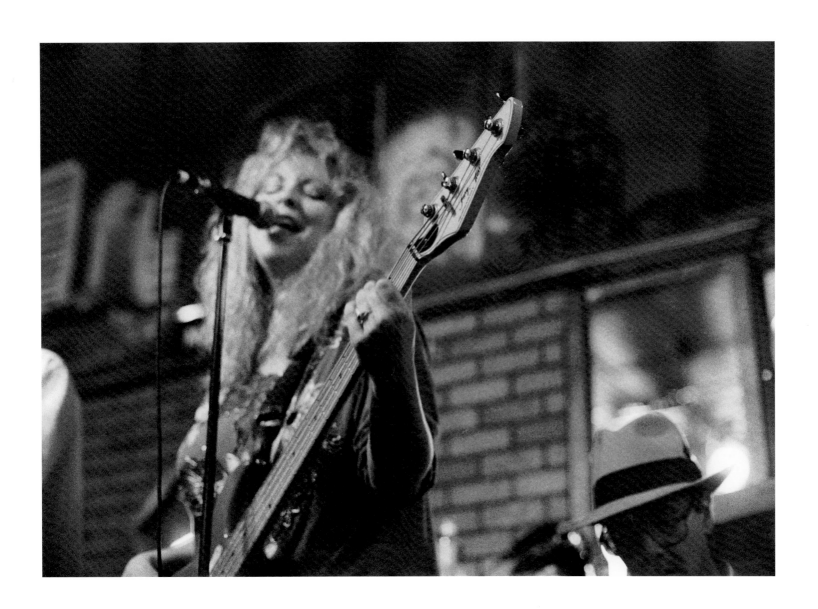

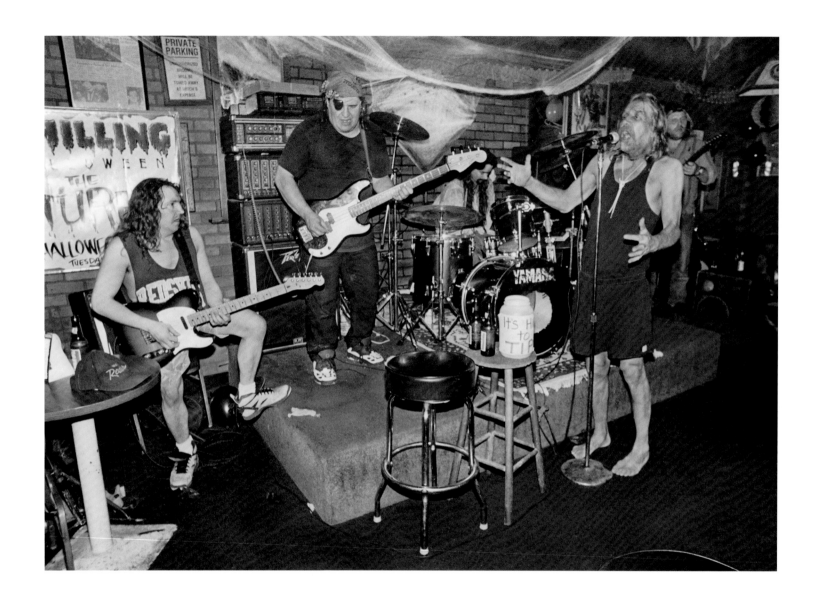

Jule Tabor sings at the Turf on Halloween.

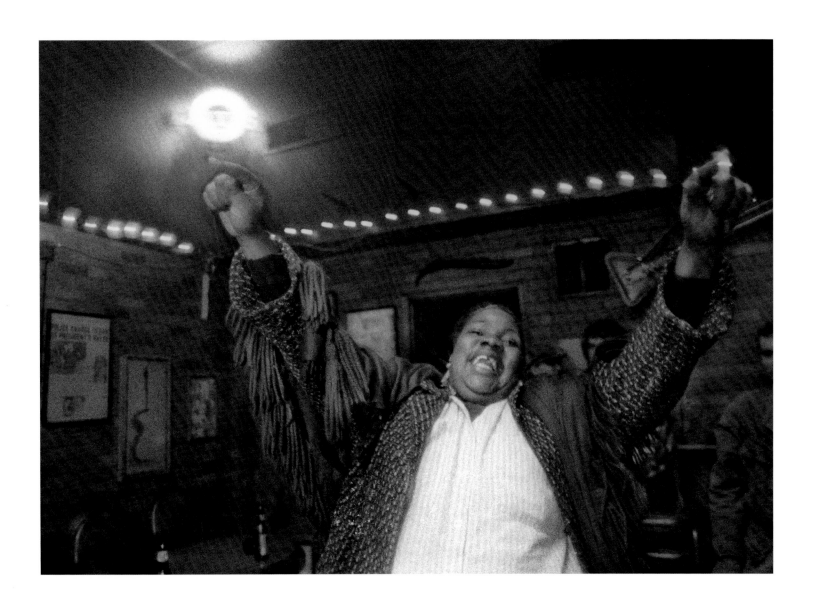

A patron rocks out at happy hour at the Turf.

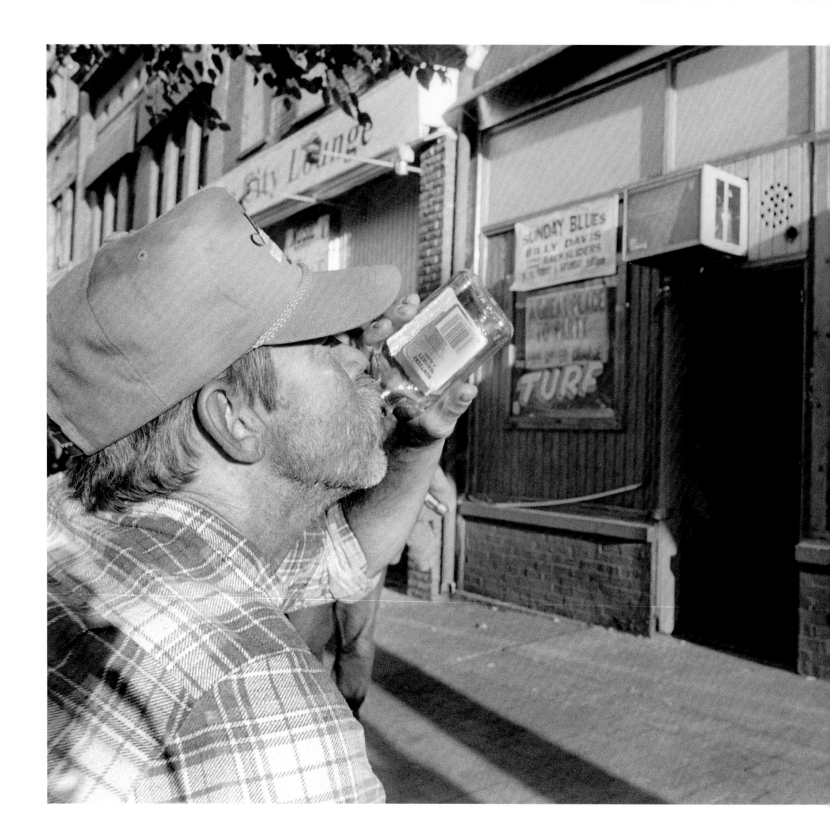

Blue-Eyed John takes a drink outside the Turf.

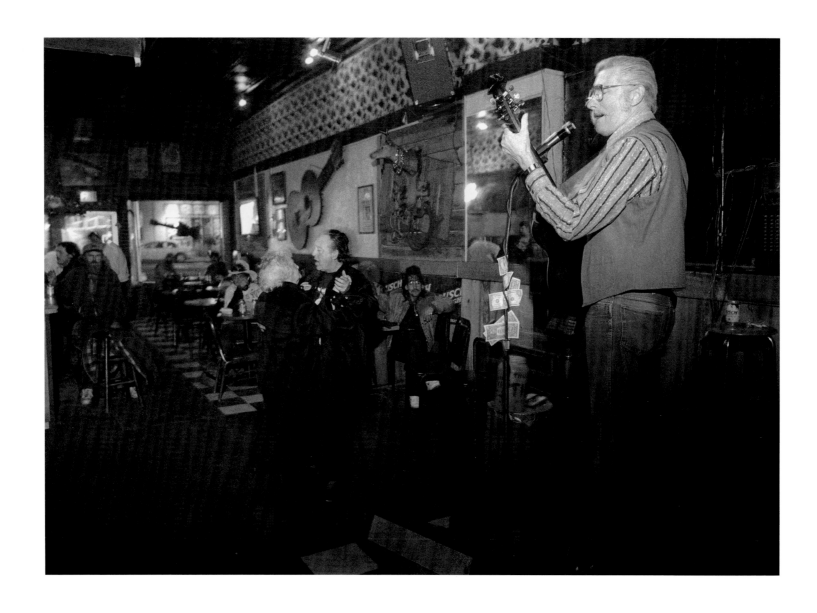

John Shepherd entertains a crowd at the Music City Lounge.

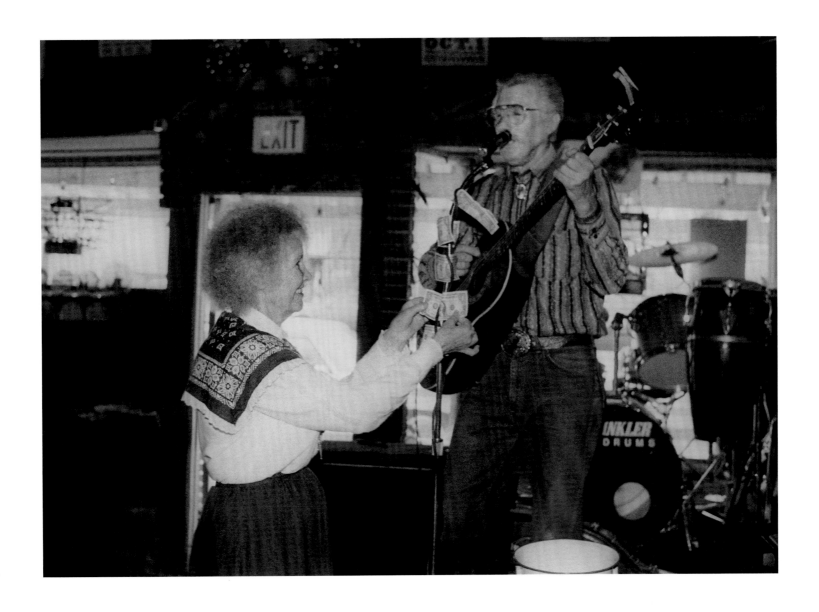

Lois Shepherd "spices" the tip jar for her husband, John.

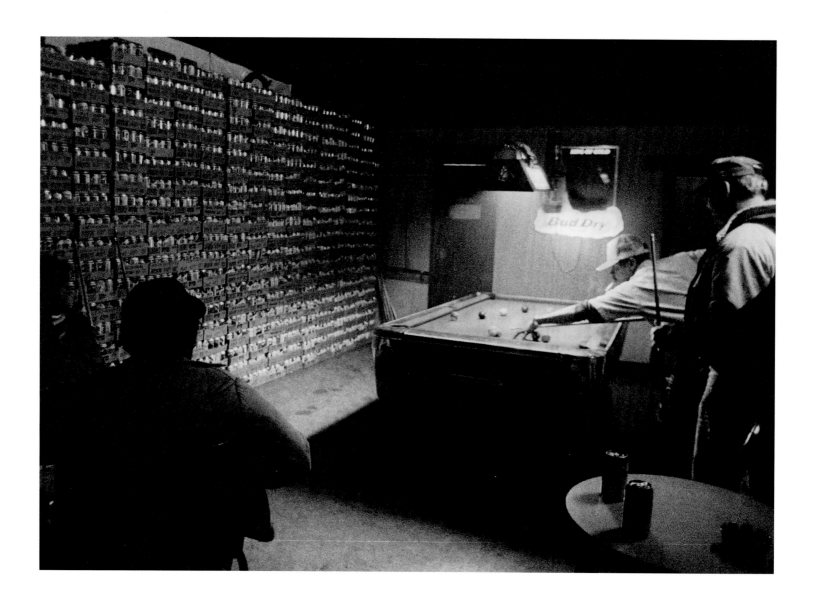

Pool players share a game near the wall of beer at the Music City Lounge.

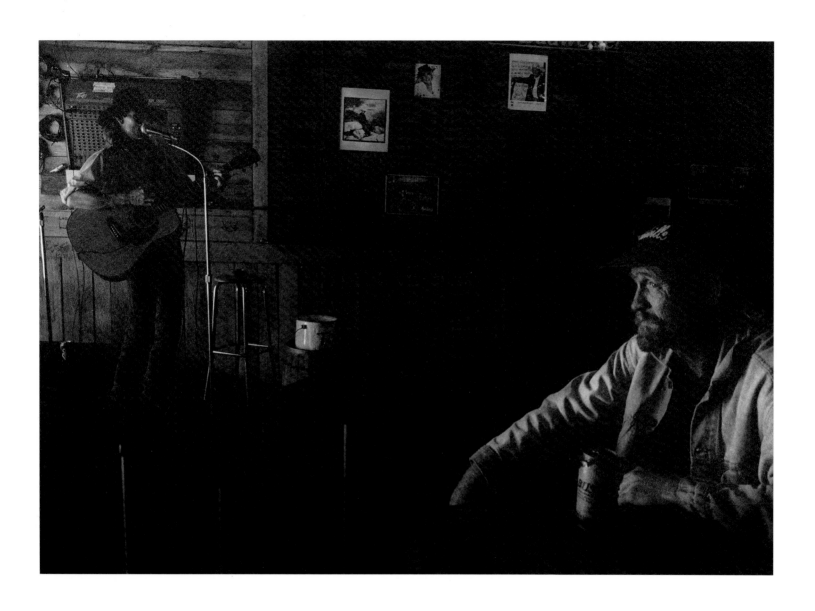

A solitary man drinks while the music plays.

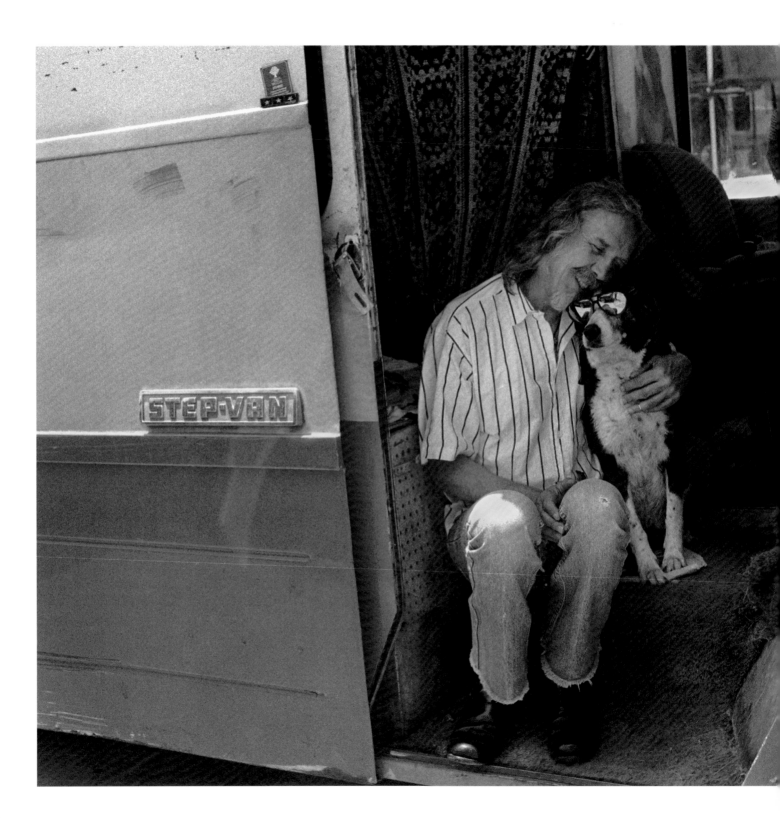

Jule and Huzzie share a tender moment
at the entrance to their home.

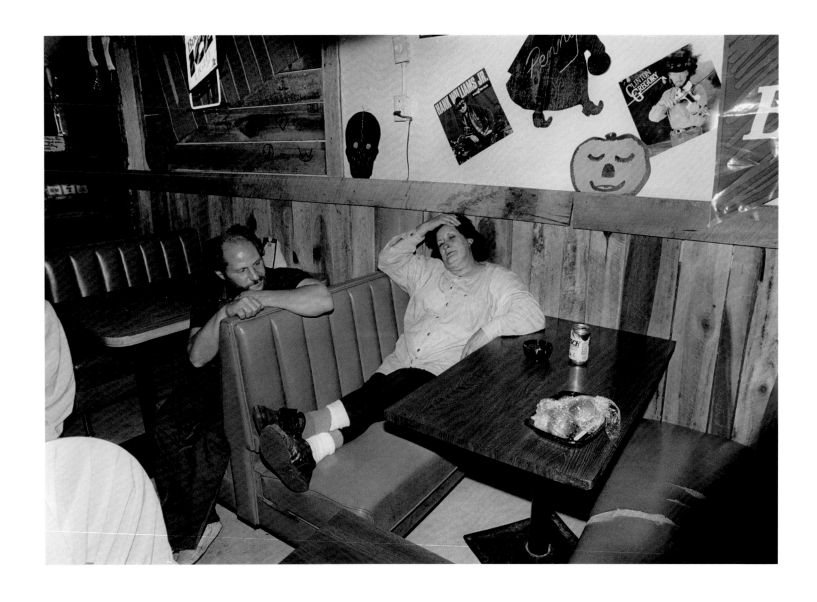

Mama Jo Eaton takes a break with a regular at the Music City Lounge.

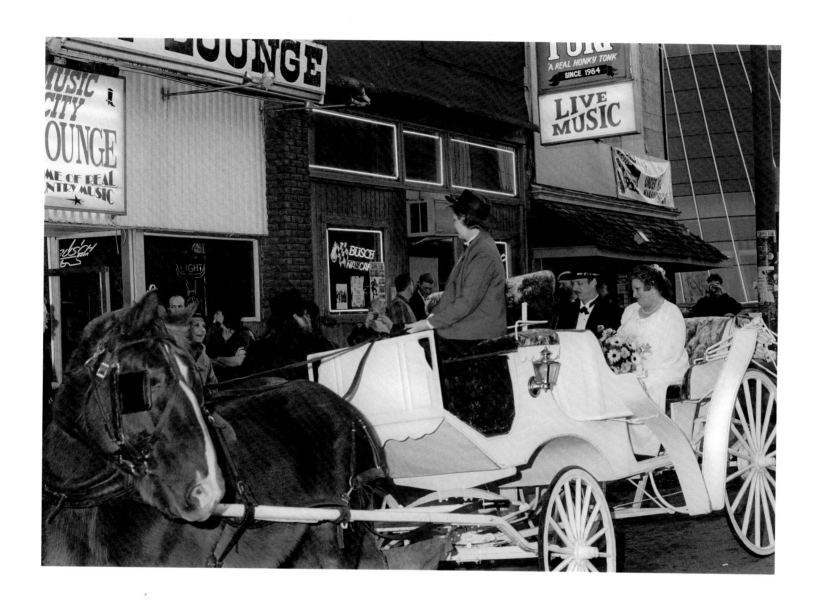

Mama Jo arrives at the Music City Lounge for her wedding on March 1, 1998.

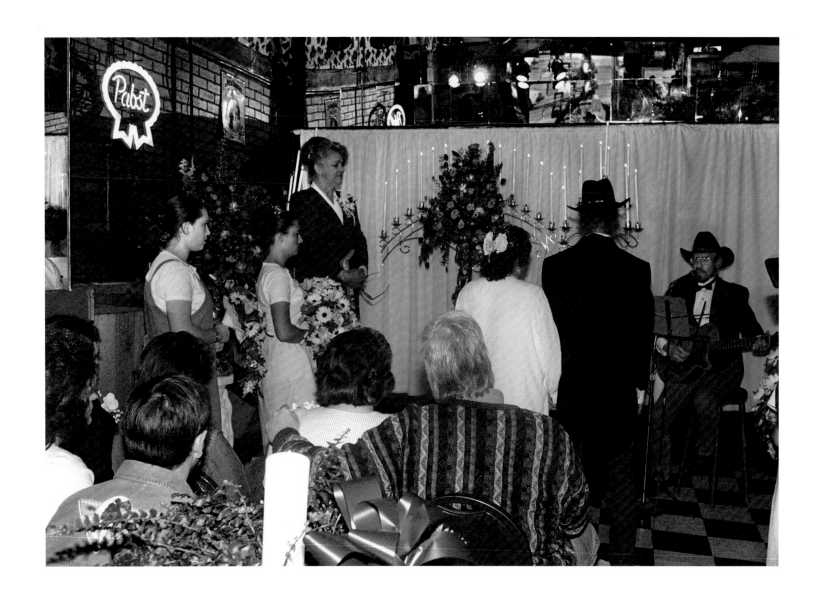

In front of the drapes hiding the pool table, Mama
Jo and Mack enjoy special wedding music.

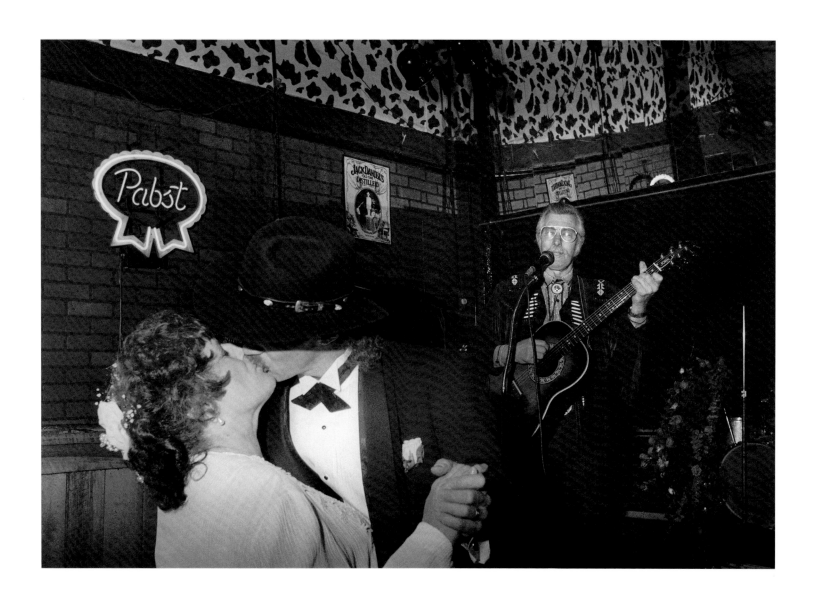

John Shepherd serenades the newlyweds as they dance.

Mama Jo and Mack take a carriage to their new life. Less than two months after this photograph was made, a tornado badly damaged Lower Broad. The Turf never reopened. The Music City struggled on for a few months, but soon it too closed, the last of the old honky-tonks on the south side of the street.

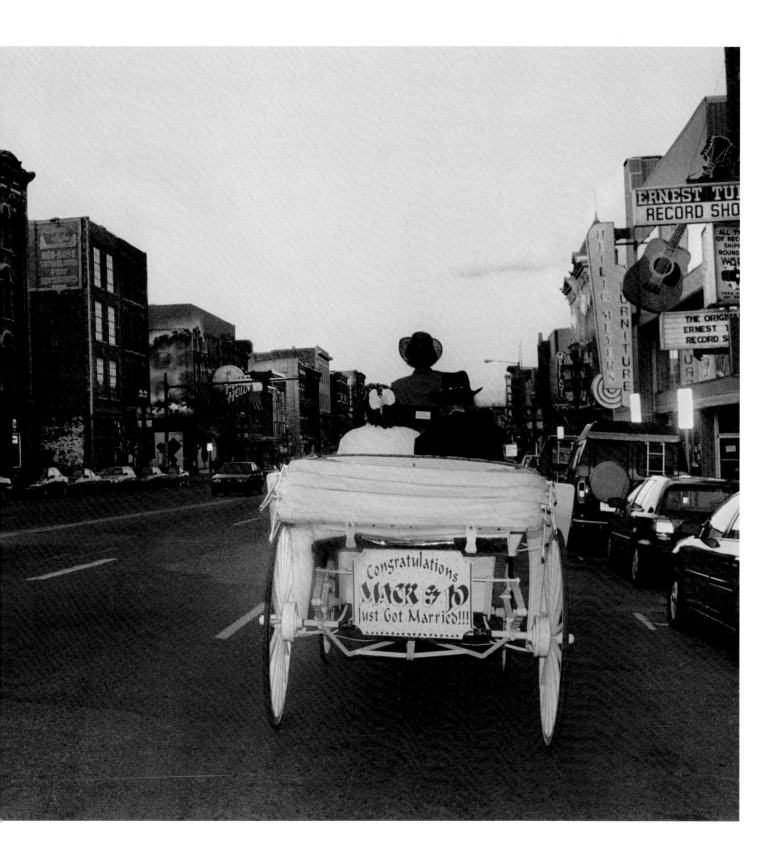

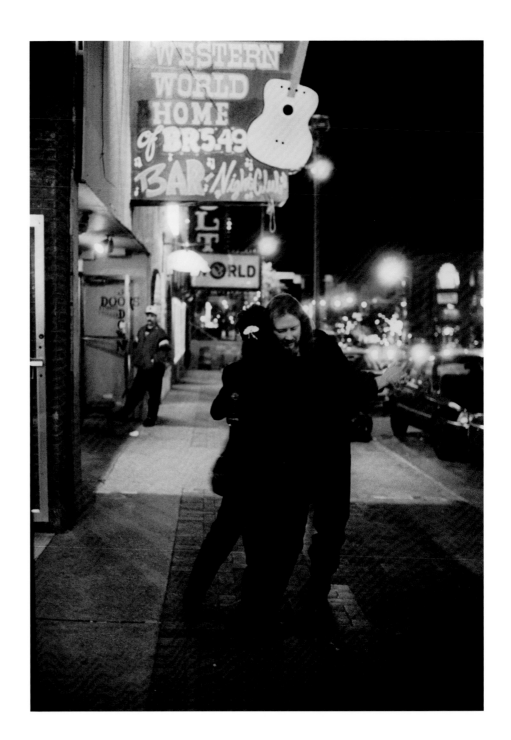

When bands like BR549 and
Greg Garing's group started
playing on Lower Broad, there
was dancing in the streets.

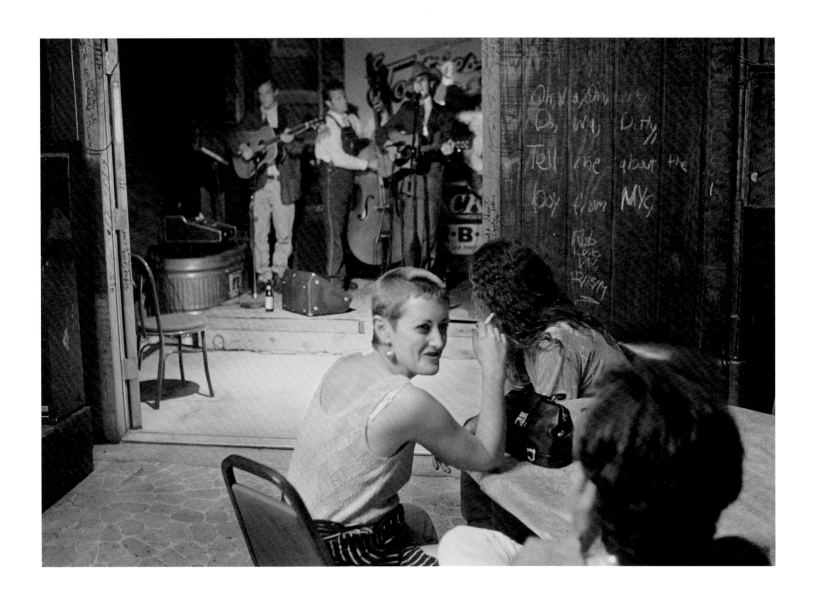

Greg Garing is Hank Williams come back to life in the
back room show at Tootsie's, and the fans love it.

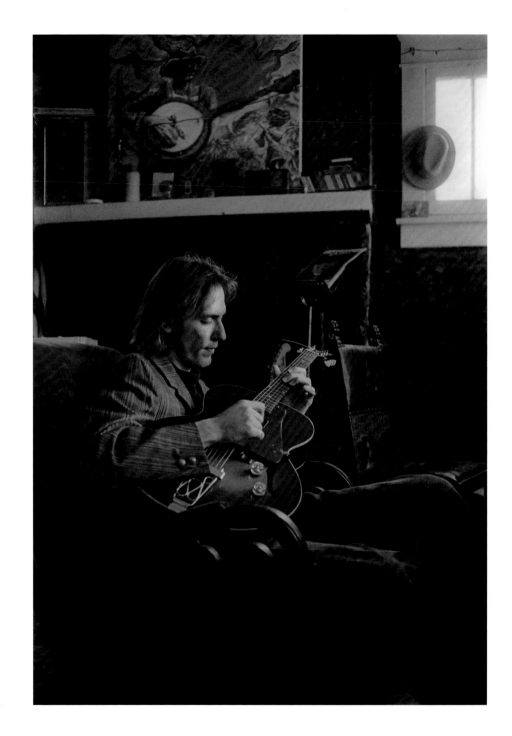

Greg practices on the guitar.

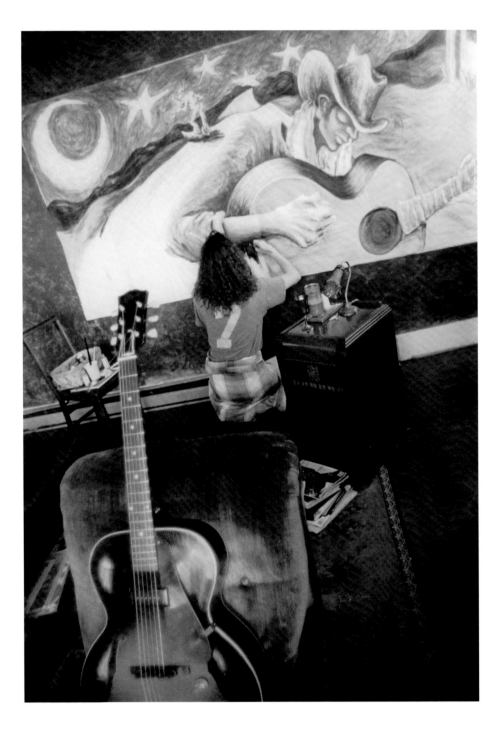

A mural celebrates Greg's Broadway success.

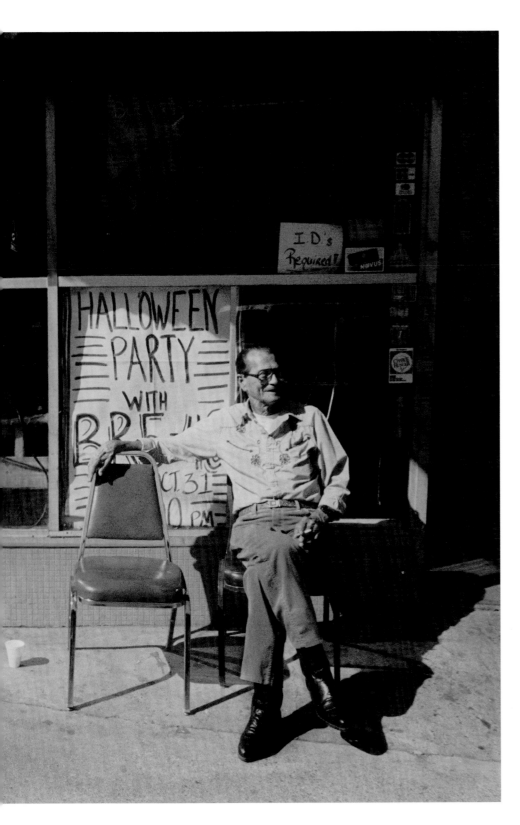

Louie Lohman and Huzzie soak up the sun outside Robert's Western World.

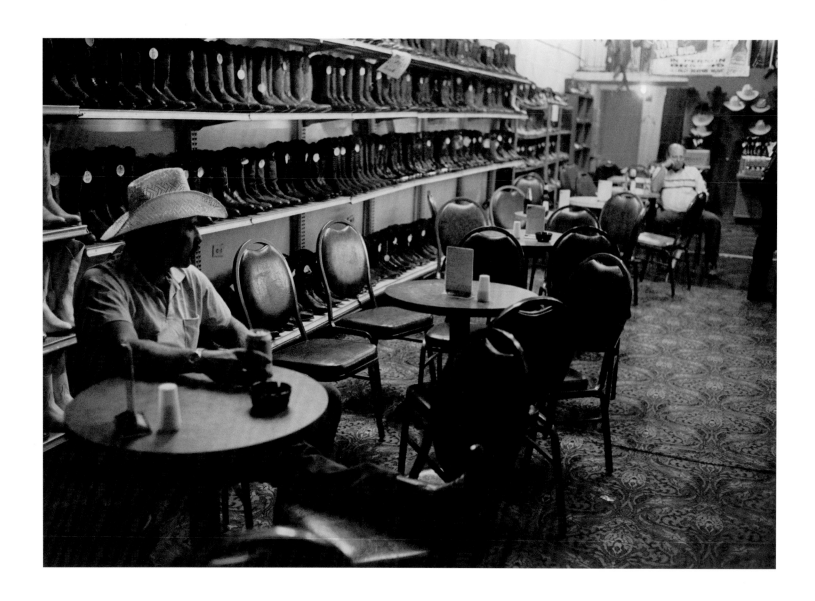

A couple of lonely guys sit in a room full of boots at Robert's in its early days.

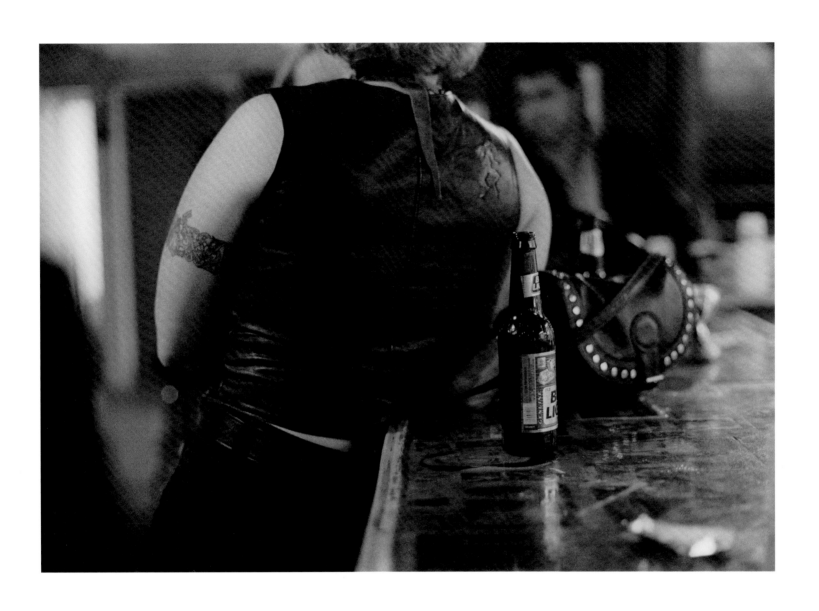

A woman at Robert's bar wears the tough leather look of Broadway's hard years.

Robert Moore, in his cowboy hat, chats with a longtime customer in front of
the wall of boots that became his honky-tonk's signature.

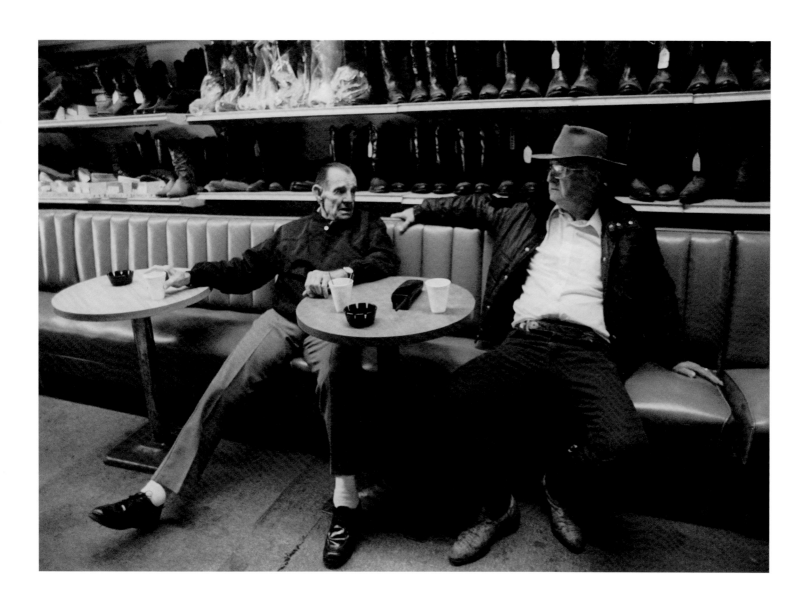

Lucinda Williams at Robert's.

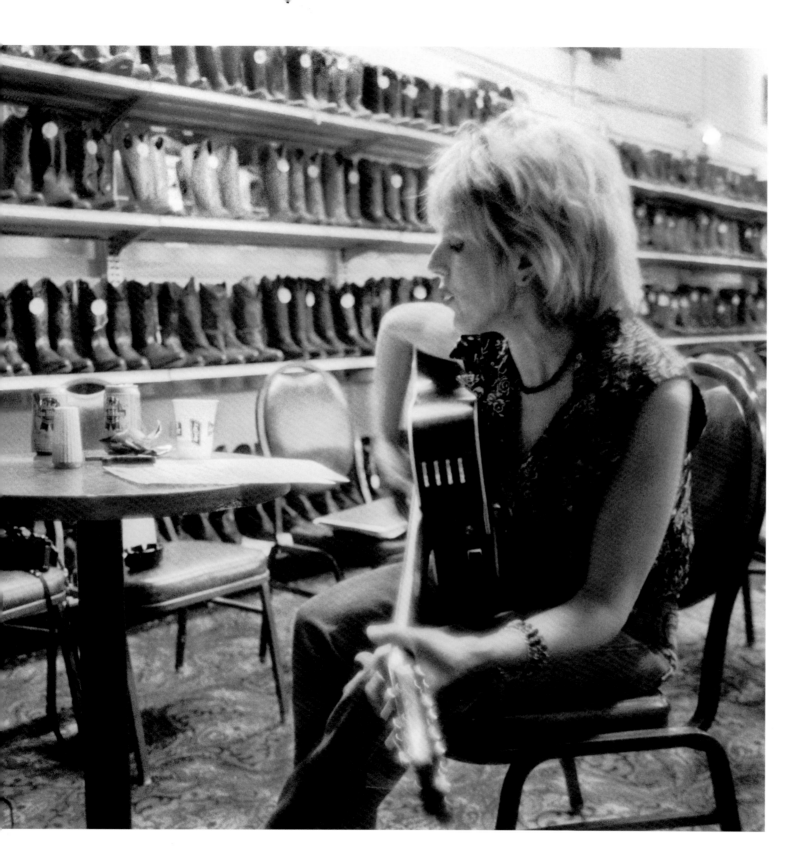

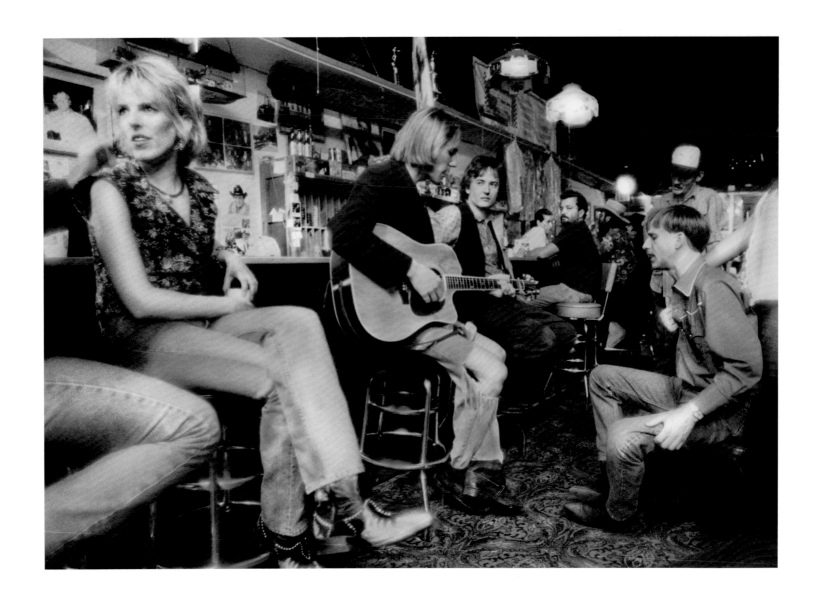

Lucinda Williams, Greg Garing, Paul Burch, and Gary
Bennett jam and talk at Robert's in the early days.

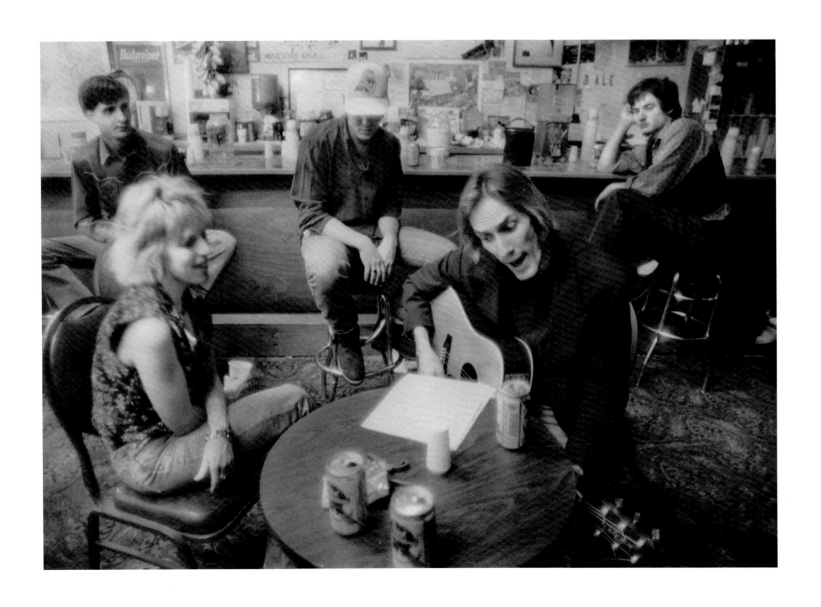

Lucinda listens as Greg sings a new song.

Gary Bennett waits on a crowd outside Robert's.

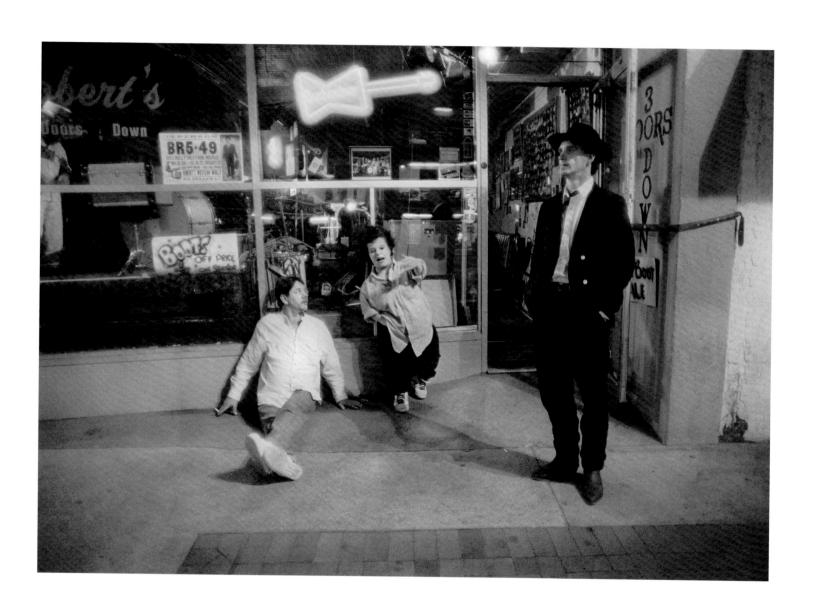

BR549 band members Don Herron and Chuck Mead try out a new tune at the bar at Robert's while Robert Abernathy, a longtime Broadway regular, and Mattie Gates look on.

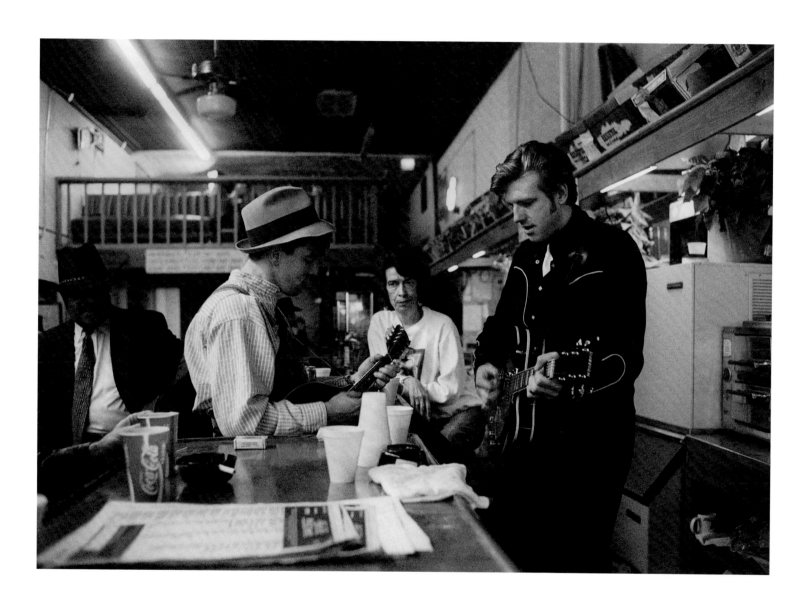

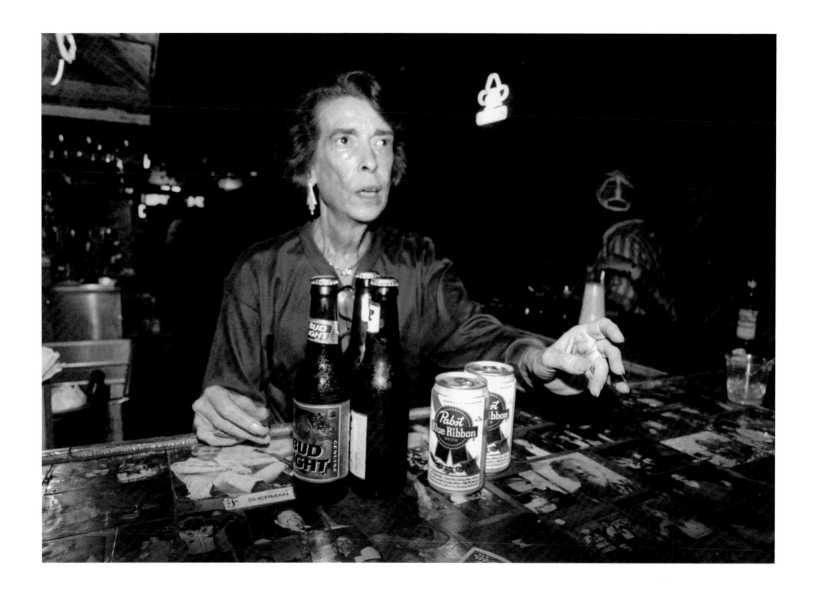

Mattie serves up the beer.

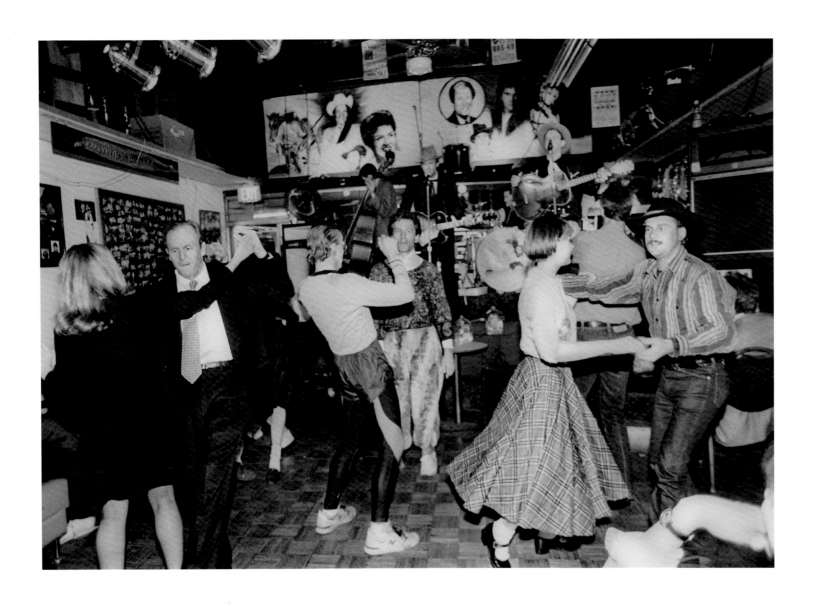

As the band heats up, the crowds grow and get more diverse.

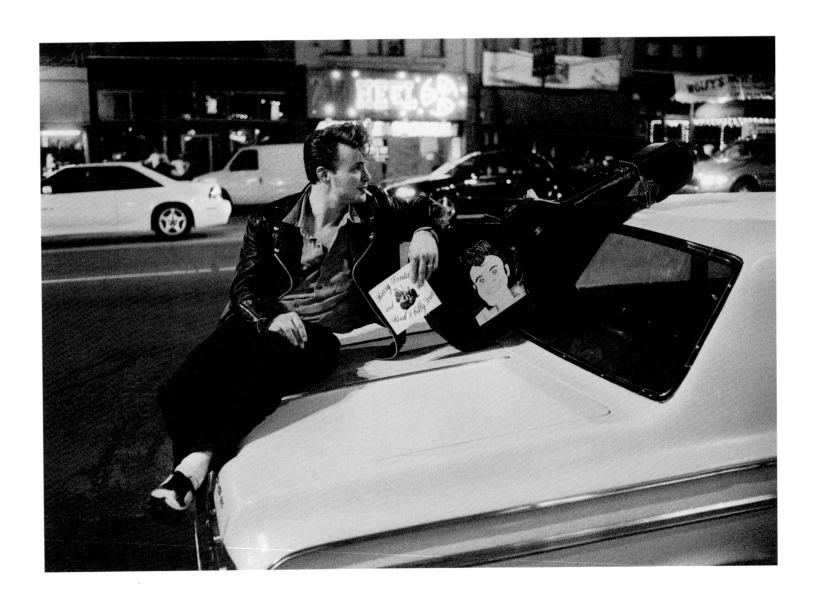

A singer-songwriter hawks his songs on Broadway.

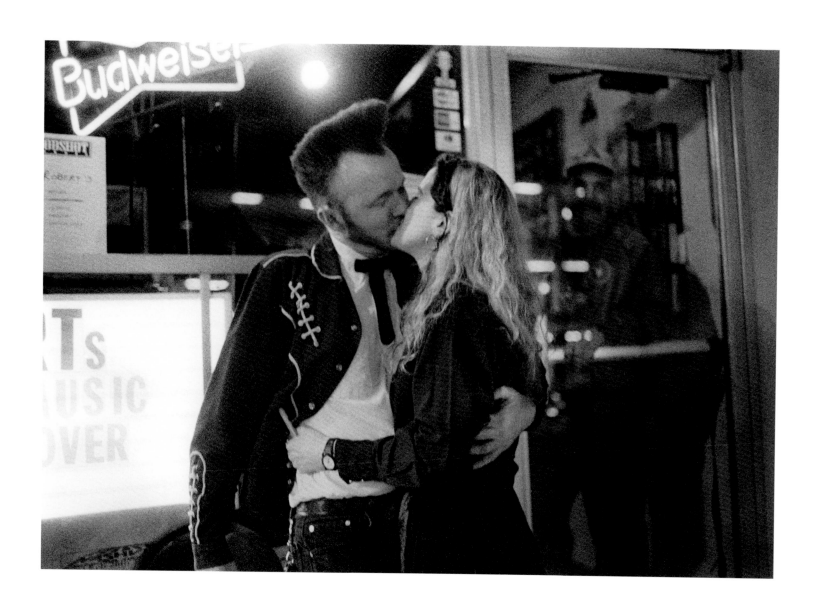

BR549 fans kiss on the street.

Some rivalry developed between Greg Garing and BR549's Chuck Mead over who should be credited with the rebirth of Broadway, and after the crowds began to come, they never played together again. Here, their energy spent, they meet on the street after gigs in different clubs.

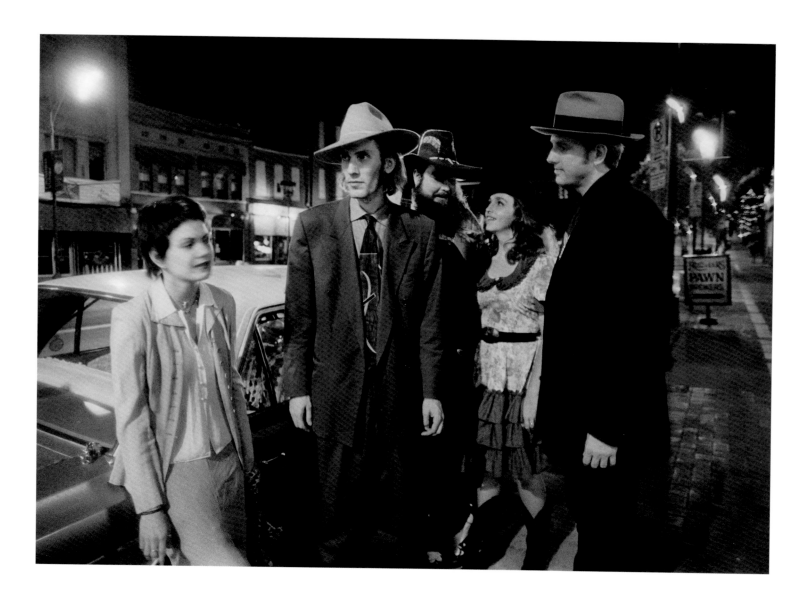

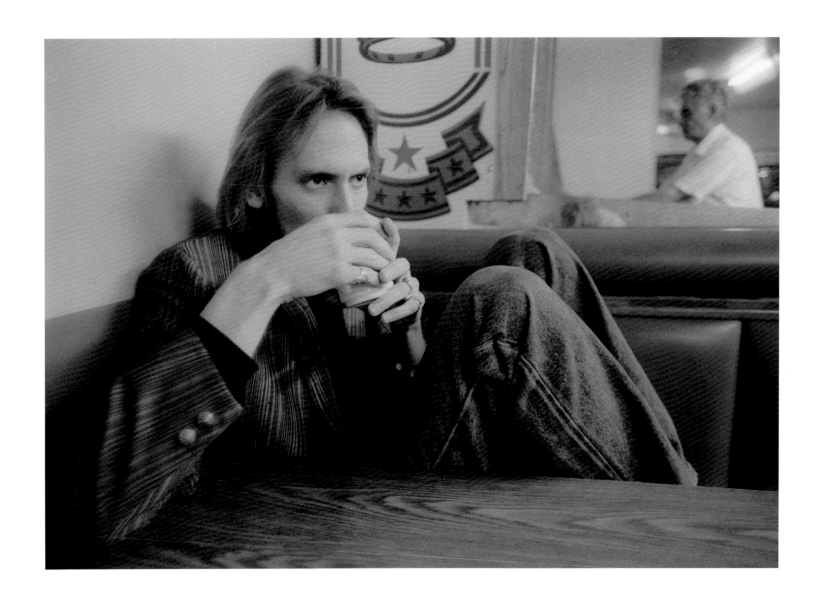

Greg Garing takes a break at a restaurant off Broadway.

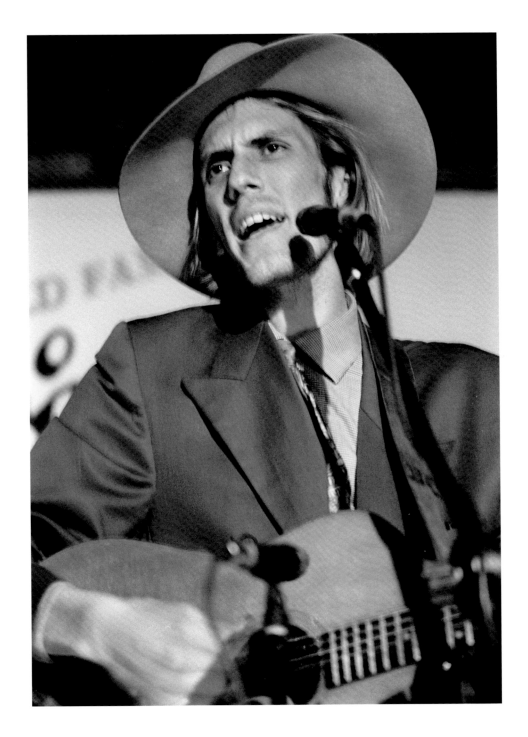

Greg is the face of a sad song.

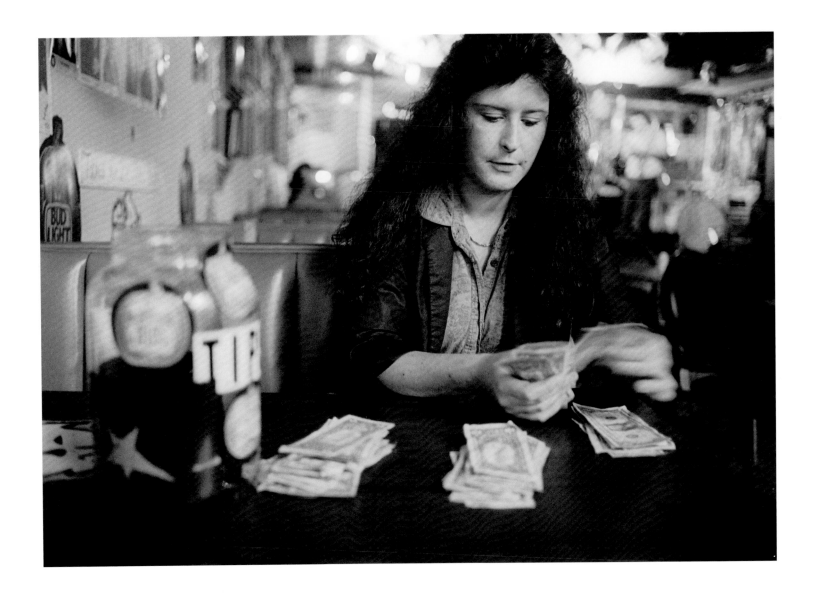

A band member's wife divides up the tip money for the band at Robert's.

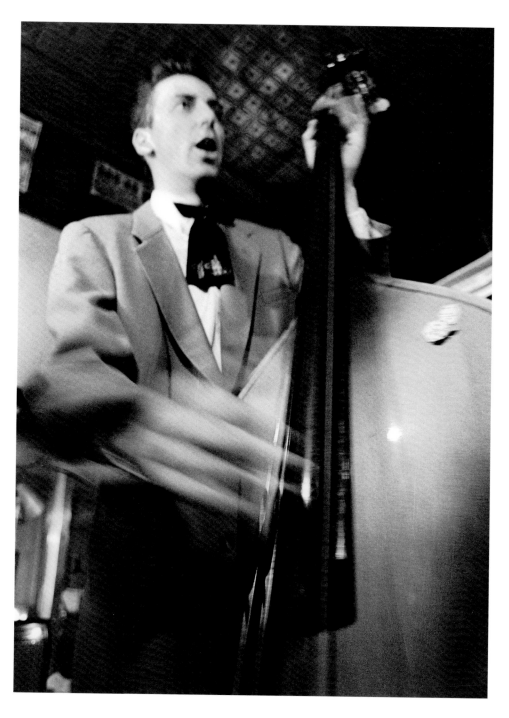

Smiling Jay McDowell keeps
the rhythm for BR549.

BR549 band members show off their Halloween costumes.

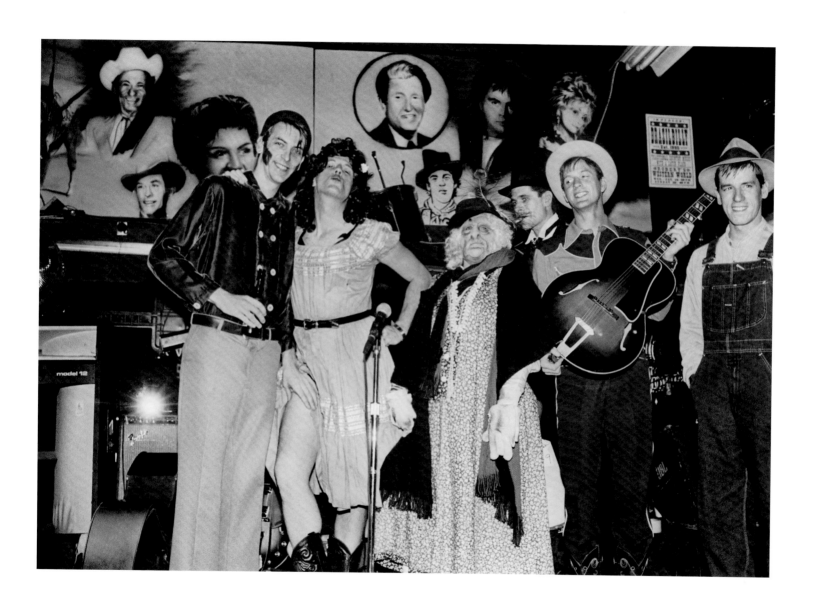

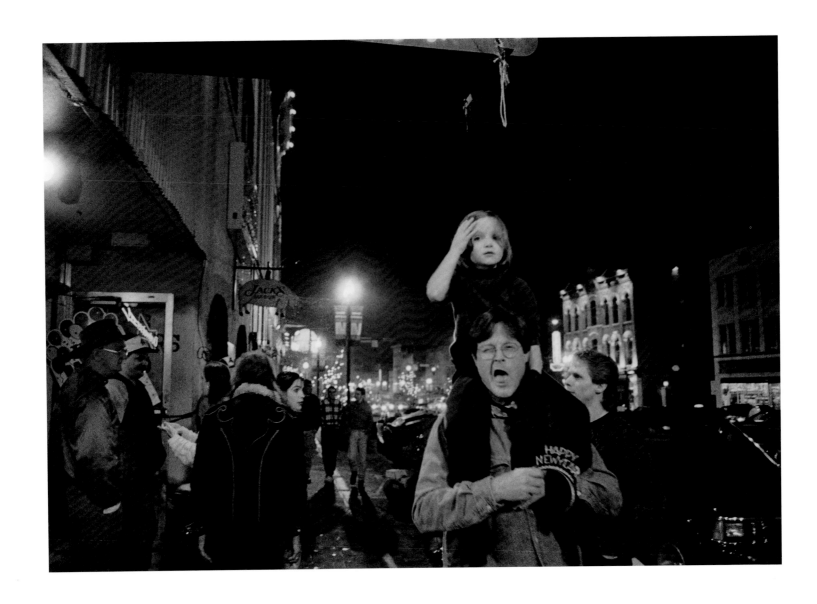

It's New Year's Eve, and there's a crowd outside Robert's.

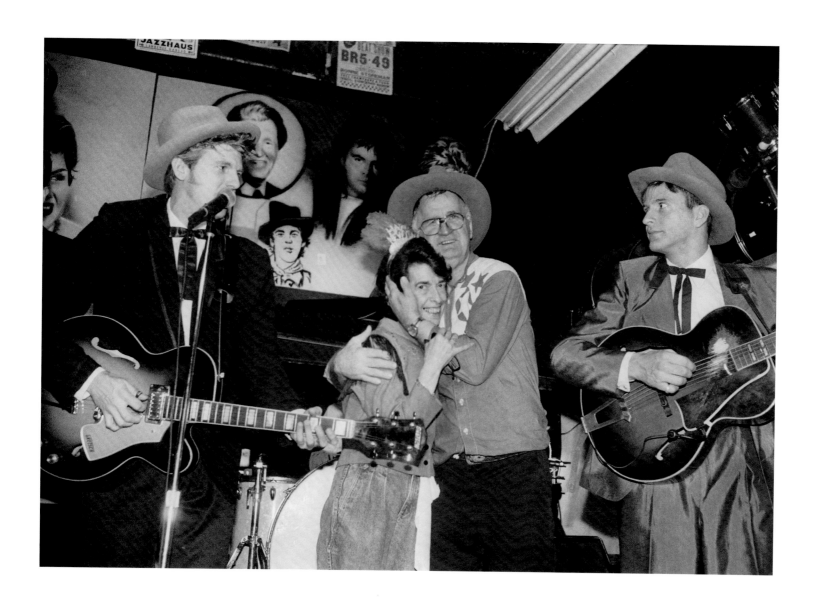

Robert, Mattie, and the band enjoy a happy moment at the stroke of midnight.

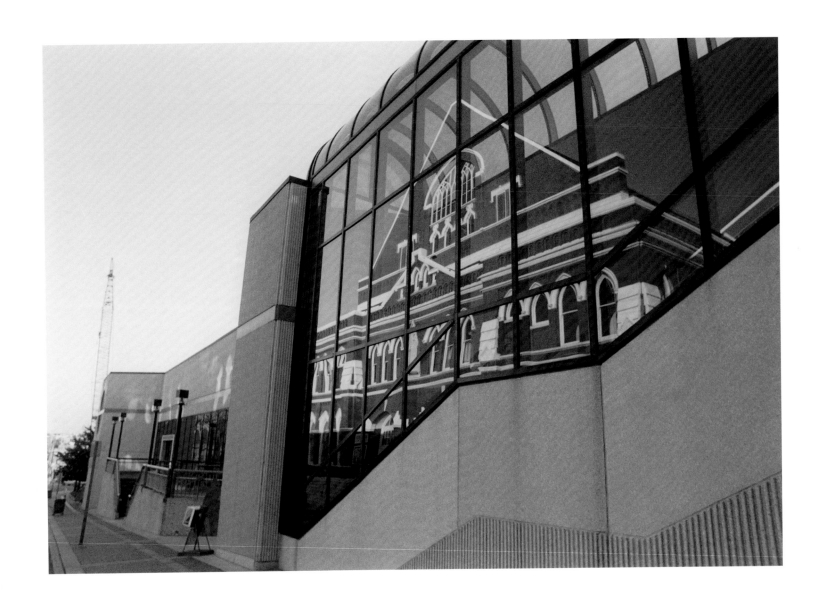

The refurbished Ryman Auditorium is reflected in the glass wall of Nashville's new convention center.

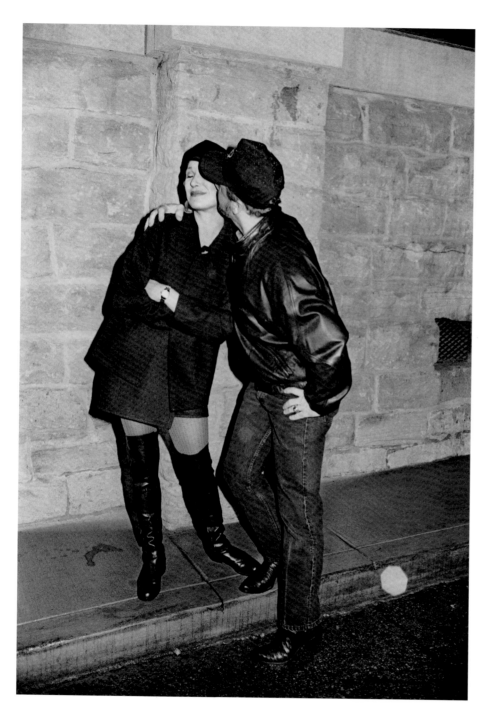

Tanya Tucker was one of the many
celebrities who came back to Broadway.

A Ryman crowd waits for Willie Nelson.

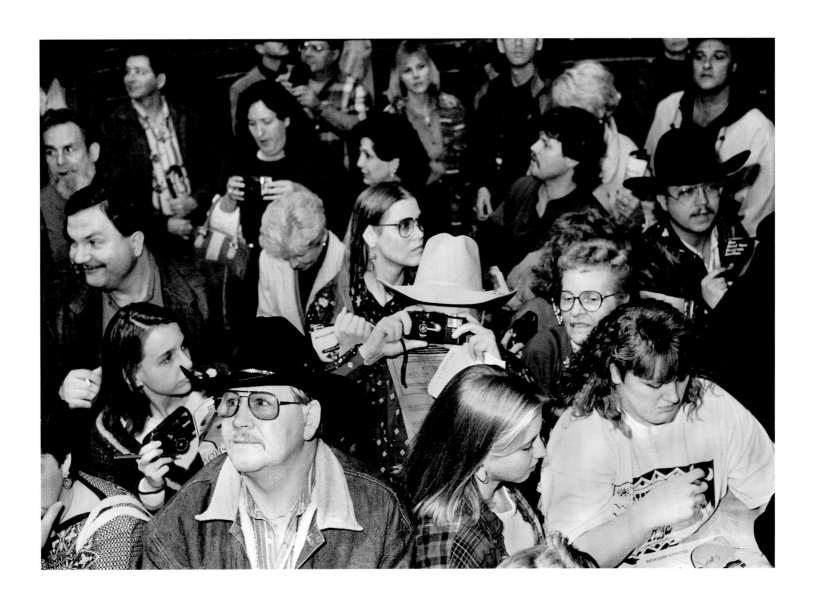

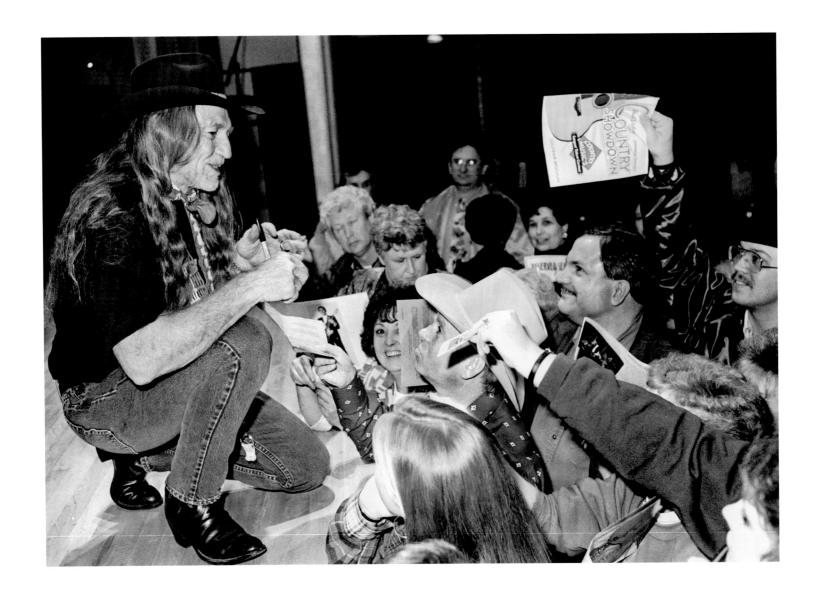

Willie greets the crowd.

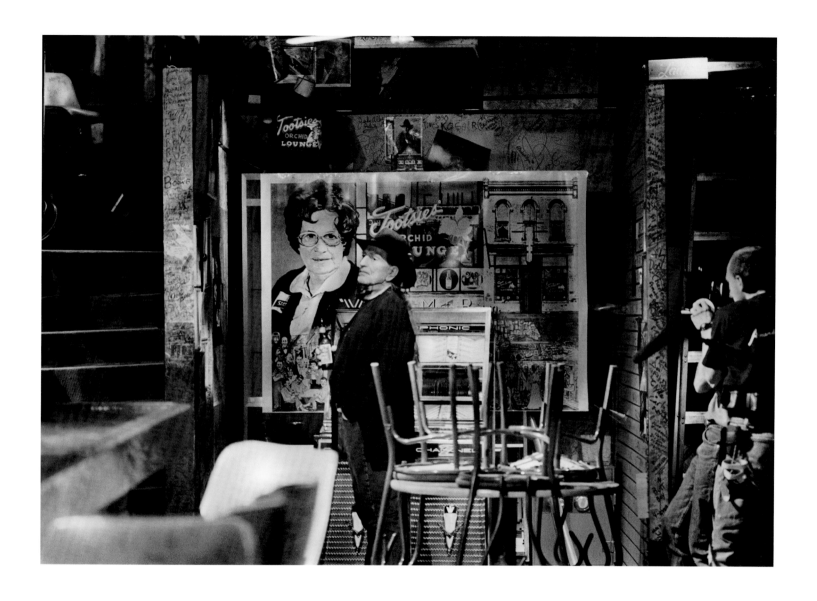

By the stairs to Tootsie's back room, Willie reflects for a moment during the filming of *Where the Music Began*, a television special about the Tootsie's scene in the 1960s.

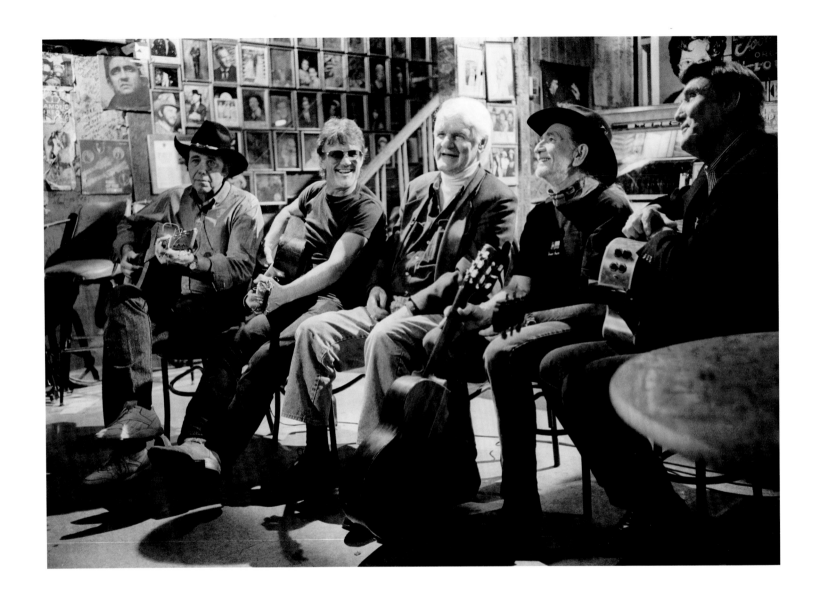

Willie sits with Bobby Bare, Kris Kristofferson, Harlan
Howard, and Billy Walker during the film shoot at Tootsie's.

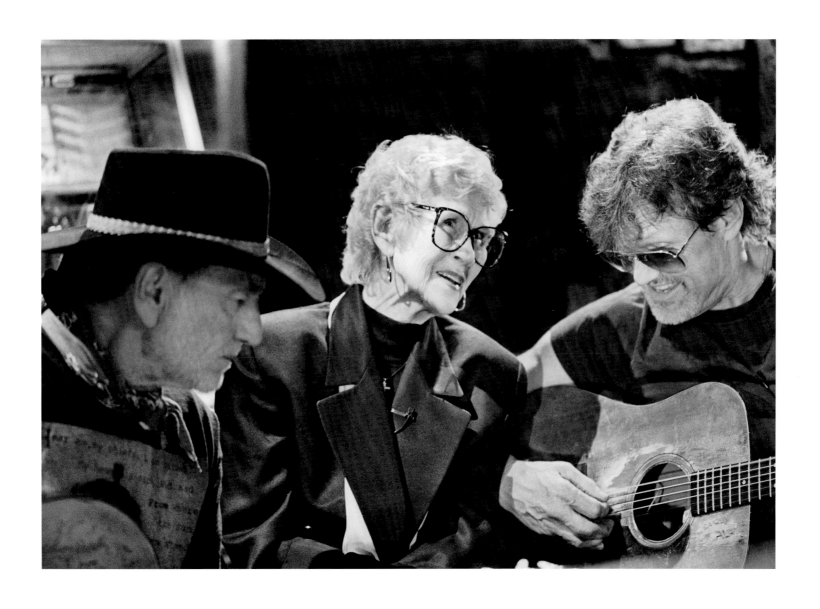

Marijohn Wilkin, who wrote "Long Black Veil," joins Willie and Kris during the filming.

Kris Kristofferson touches a blind girl's hand during a break in filming.

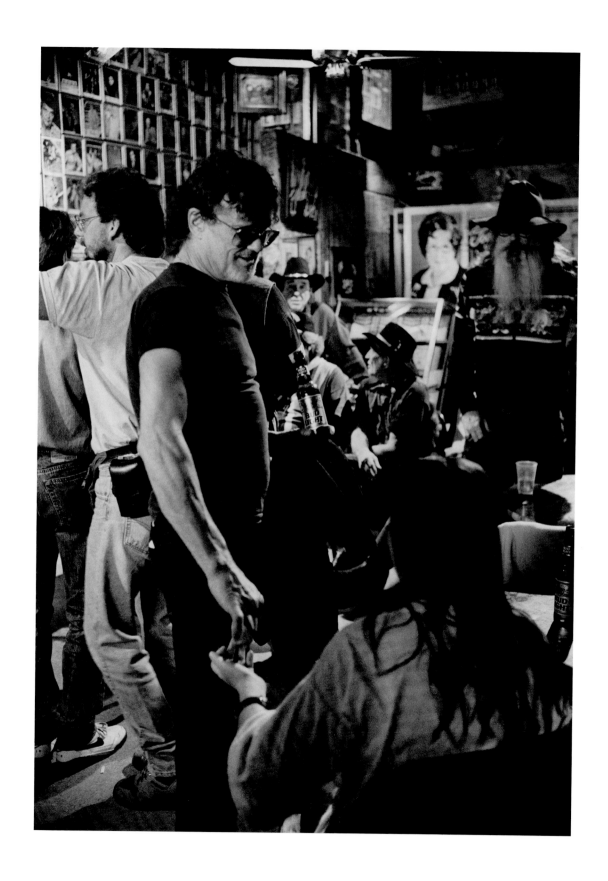

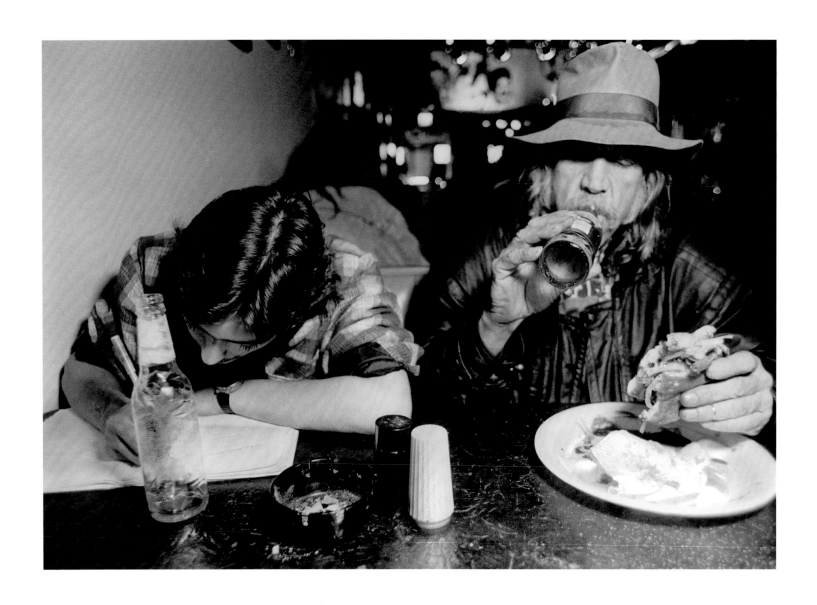

Jule Tabor tackles a burger while his friend writes a song.

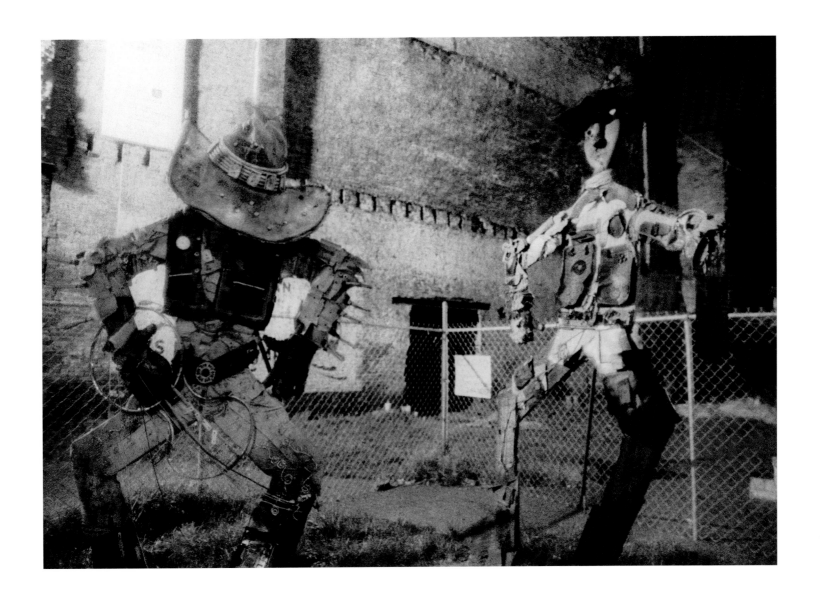

Whimsical figures made from found objects, items discarded on Broadway during its hardest years, ornament the lot next to George Gruhn's guitar store.

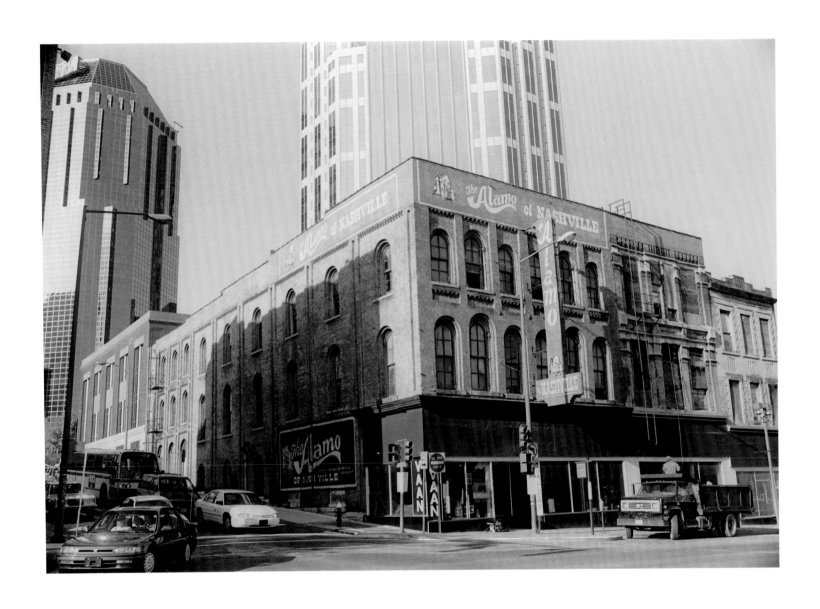

The Alamo building as it stood in November 1995.

118

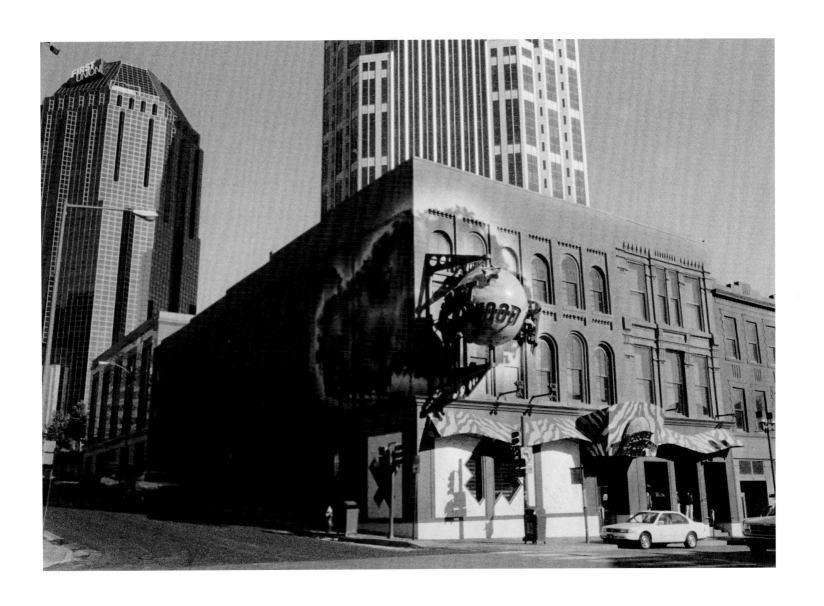

The Alamo becomes Planet Hollywood.

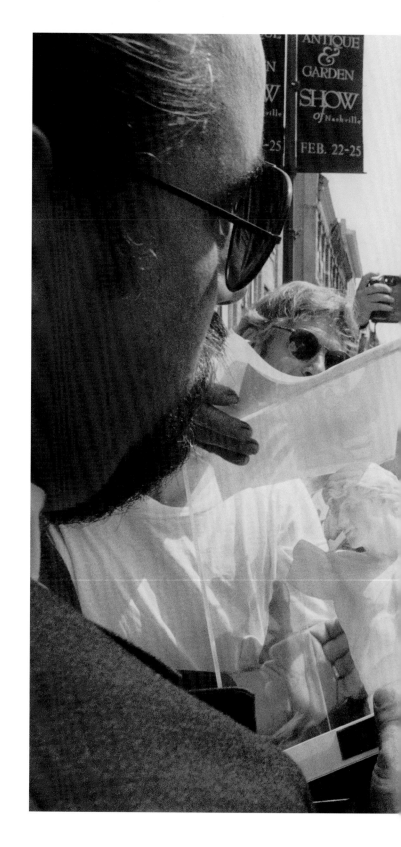

Sylvester Stallone signs autographs outside Planet Hollywood at its grand opening in June 1996.

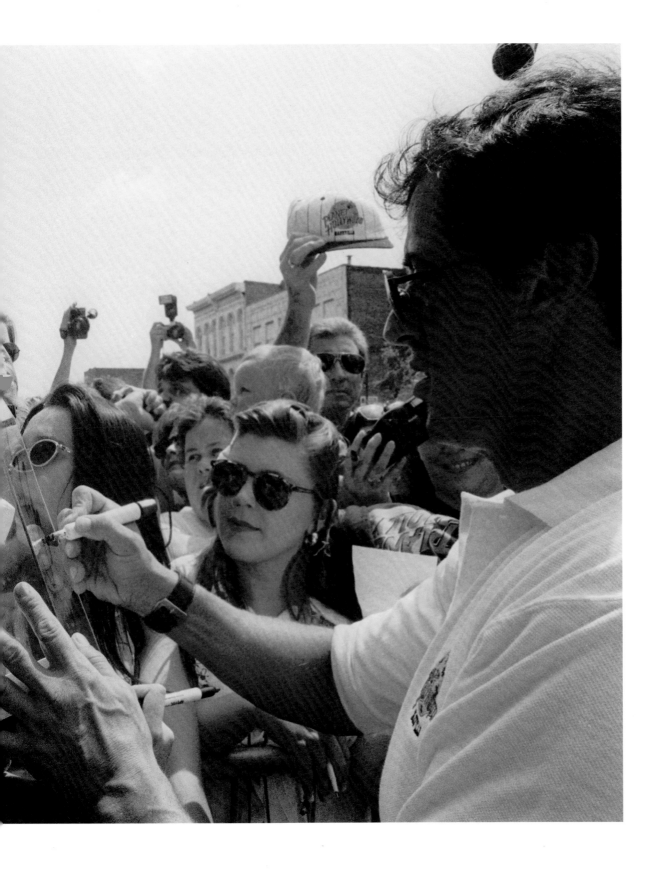

The old Adult World is now the Stage, the largest music venue on the street.

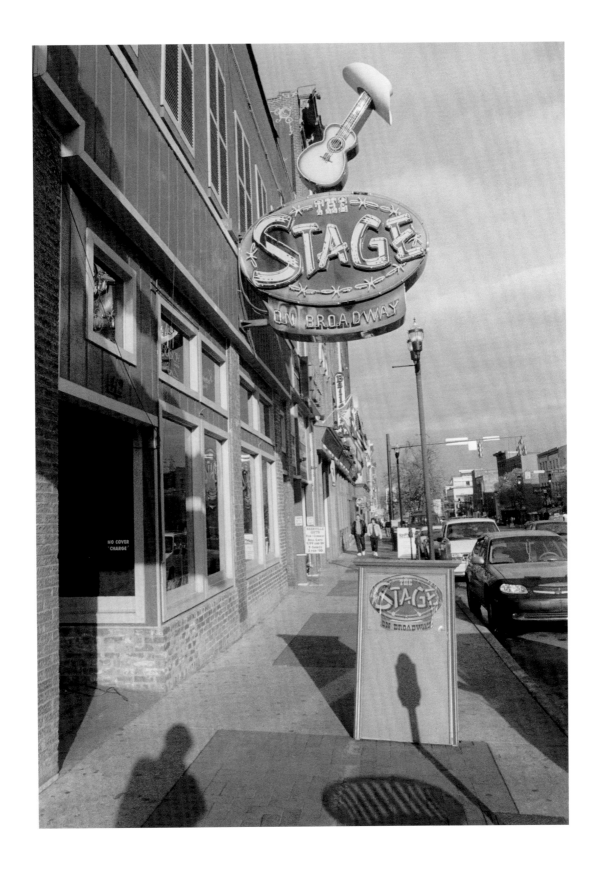

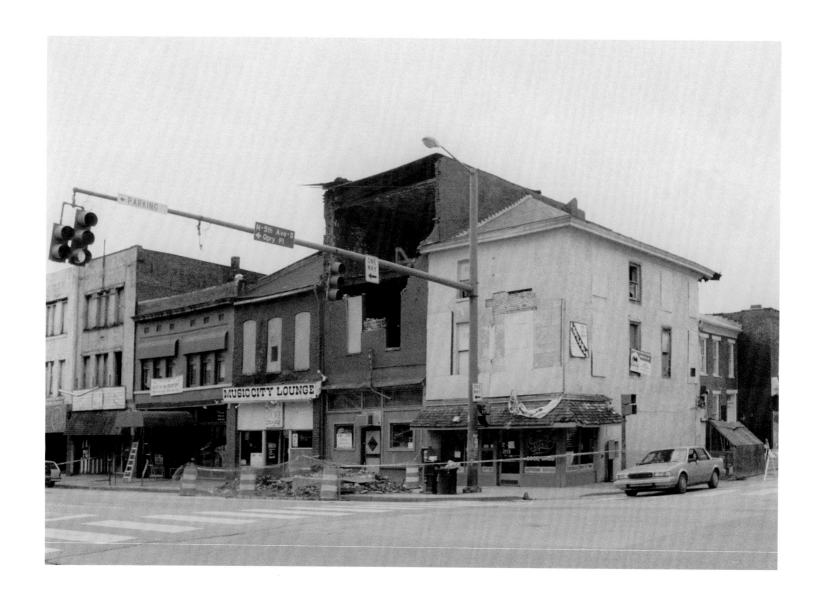

The south side of Lower Broadway
after the tornado of 1998.

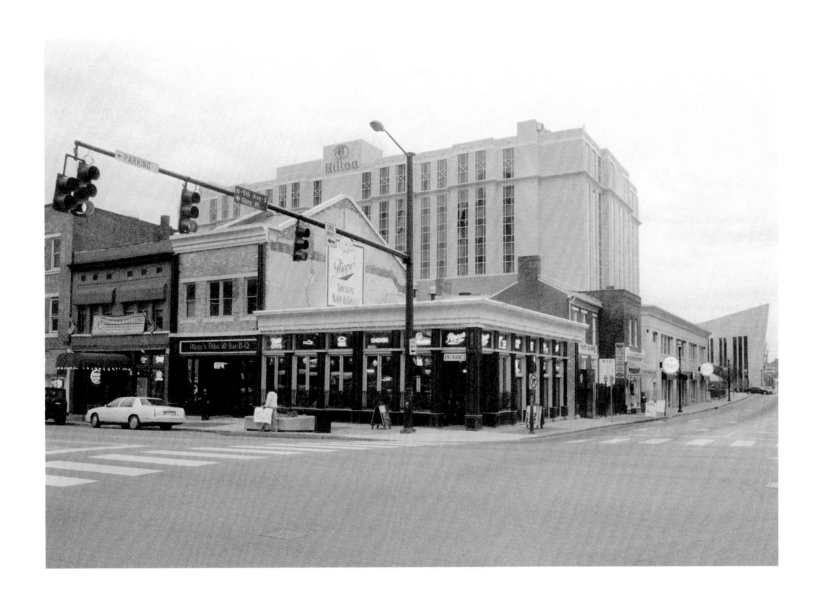

A barbecue place has displaced the Turf and the Music City Lounge. That's the Hilton Hotel behind it and the new Country Music Hall of Fame to the far right.

The new face of Broadway: Steve Smith, the
owner of Tootsie's, celebrates New Year's Eve.

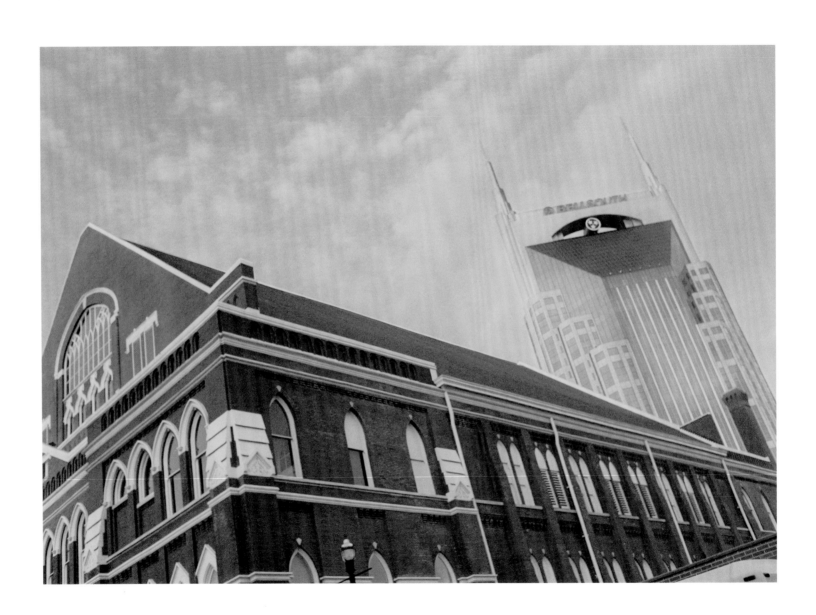

Broadway moves on.

ACKNOWLEDGMENTS

The photographs in this book cover a journey of nine years during which I compiled close to ten thousand frames. Throughout this time I was fortunate to have had the support and encouragement of many gracious and wonderful friends. Without them this book would not have been possible.

I first must thank my longtime songwriter friend, David Foxworthy, who invited me to a party in Nashville where I met Lucinda Williams. Thanks, Lu, for all you have done and for sharing your words in this book. Thanks also to Dub, R.B., and the Rocket Man, Kevin—here's to friends, luck, and circumstance!

On Lower Broad a special thanks to the Minstrel Man, Jule Tabor, my honky-tonk mentor. To Robert Moore, Mattie Gates (now deceased), Mama Jo Eaton, John and Lois Shepherd, Greg Garing and his band, and the members of BR549, thanks for allowing me into your world. Also, Miss Pat, Louie (now deceased) and Wanda, Blue-Eyed John (also deceased), and countless others whose faces and stories I will never forget. Also, thanks to George Gruhn, Bob "Wolfy" Wolf, Steve Smith, and Toby Carr for their interest and input.

In Nashville and around Tennessee I had great encouragement from Dr. Charles Wolfe, Dr. Robert "Roby" Cogswell, Ann Roberts, Lois Riggins-Ezzell, and Scot Danforth. Special thanks to Dr. David Eason for his research, his introductory essay, and overall help with this project. I would like to thank Wesley Pane at The Parthenon and Tom Jimison at Baldwin Gallery for exhibiting my photographs.

I am especially grateful for the advice and guidance from fellow photographers and others in the photography community throughout the country. Photographers Constantine Manos, Sam Abell, Bill Wright, and Joe Baker graciously shared their vision and wisdom. Leah Ben-David Val and the folks in Santa Fe shared their encouragement and advice. Many thanks to Robert Liles for making my exhibit prints and to Frederick Park for his tireless effort in making the image scans for this book.

At Smithsonian Books, I want to thank Caroline Newman, for first believing in this book, and Emily Sollie, for keeping the loose ends tied together. Thanks also to Gretchen Smith Mui for her editing, Janice Wheeler and Brian Barth for their design, and Carolyn Gleason, Joanne Reams, and Eric Schwass for supervising production.

At home in the Carolinas, a warm thank-you to my family, especially my mother and sister, who have always been supportive of me even when they did not understand me. To all my nieces and nephews, grand and otherwise, you have always been a joy. An extra acknowledgment to Sammy for helping edit. Thanks also to my high-school friends, Al and Martin, who first showed me how special the music can be.

Last, I want to thank my wife, Dianne, who joined me midway through this project but without whose help and love I could not have finished this book.

I would like to dedicate this book to my mother, Margaret Rouda Kelley; to the memory of my father, Bill Rouda Sr., my grandmother Ada Rouda, and my brother-in-law Sam Fretwell, whose spirits have been with me throughout this journey; and to all the poets and pickers without whom this book would not have been possible.

—Bill Rouda

I owe a special debt to the following people who sat down with me and recorded their reflections about their time on Broadway: Gary Bennett, Toby Carr, Hank Cochran, Mattie Gates, George Gruhn, Mama Jo Eaton, Kathleen Moore, Robert Moore, R. B. Morris, Frank Oakley, H. G. "Squire" Phillips, John and Lois Shepherd, Buddy Shupe, Jule Tabor, Marijohn Wilkin, and Bob "Wolfy" Wolf. Before this book could be published, Mattie Gates and Buddy Shupe died. John and Lois Shepherd gave me more time than I had a right to ask for; I could not have written this essay without them. Ann Roberts of the Nashville Historical Commission and Robert "Roby" Cogswell, director of the folklife program of the Tennessee Arts Commission, offered background and encouragement for this project. *The Tennessean* allowed me to look at old clippings about the street, and Annette Morrison of *The Tennessean* Library staff guided me through the system. I also benefited from the holdings of the Nashville Room of the Metro Public Library. My friend Michael Gray, staff member at the Country Music Hall of Fame, helped in countless ways. Middle Tennessee State University provided a summer research grant and a noninstructional assignment during the time of this project, and Kathy Keltner and Brad Stephens provided research support.

—David Eason